# HOW TO DRAW SHARPIE ART

## Do-It-Yourself Colorful Creations

### JESSICA MAZURKIEWICZ

Racehorse Publishing

Racehorse Publishing books may be purchased in bulk at special discounts for sales promotion, corporate gifts, fund-raising, or educational purposes. Special editions can also be created to specifications. For details, contact the Special Sales Department, Skyhorse Publishing, 307 West 36th Street, 11th Floor, New York, NY 10018 or info@skyhorsepublishing.com.

Racehorse Publishing™ is a pending trademark of Skyhorse Publishing, Inc.®, a Delaware corporation.

Visit our website at www.skyhorsepublishing.com.

10 9 8 7 6 5 4 3 2 1

Library of Congress Control Number: 2019912314

Cover design by Kai Texel
Cover and interior photography by Jessica Mazurkiewicz

Print ISBN: 978-1-63158-354-4
Ebook ISBN: 978-1-63158-355-1

Printed in China

# CONTENTS

# INTRODUCTION

I first realized the transformative power of Sharpies in my terrible tweens when I stubbornly insisted on a flimsy backpack, which, of course, meant the straps broke very early in the school year. Embarrassed by my blunder, I decided to decorate my bag to distract from the fact that it no longer functioned as a backpack and instead had to be carried more like an infant. I started with one doodle, and before I knew it the entire bag was covered in art, much like a tattoo sleeve. Yes, the backpack was replaced the following year, but the experience and delight in creating something so uniquely personal stuck with me. I also learned a wonderful lesson about how an object can be re-imagined, re-invented, and re-used by adding some decoration and personal flair.

I hope that you enjoy these ideas and that they are a great jumping-off point for your own designs. Remember, there are no rules—just embrace the imperfect. The charm in something hand drawn is that it is unique and not mass produced.

Happy Drawing, Doodling, and Creating!

—Jess

# CHAPTER 1

# MATERIALS AND GETTING STARTED

**Markers, markers, markers, and of course something to decorate**

So you're probably wondering why a whole chapter is devoted to supplies . . . don't you just need a marker and something to draw on? The answer is of course, yes . . . and no. Amazing things can be created with just one marker and a surface to decorate, but there are many additional supplies and tools that can enhance your Sharpie experience.

It's also lovely to have a variety of colors and brush tips to layer with and to vary line thickness. For instance, if you want a large area of solid color it would be silly to use a Fine tip marker to fill it in when a big chunky marker will make quick work of the job.

There are a variety of marker tips to choose from:

- Fine
- Ultra Fine
- Brush
- Chisel
- Super

When choosing a marker, you want to consider the size of the object you are decorating and also the kind of lines that you would like to draw. You also want to consider the surface that you are decorating. For example, you want an oil-based marker for decorating ceramics and glassware and a stain marker for decorating fabric. Test your marker on a material similar to the surface that you will be decorating, if possible. For instance, if you're going to be working on fabric don't test on paper because inks react differently depending on the surface type. Testing the color is always a good idea as well. There is often a difference between the cap color and the ink color.

To get the most out of your markers, make sure to close their caps securely. Horizontal storage is best for the longevity of the ink.

## A SURFACE TO DECORATE

Before going online or out to the store for items to decorate, check your give away/discard/donate pile and local garage sales. Many items can be revitalized with a coat of spray paint, and a freshly painted surface is a delight to decorate. Even items that seem too shabby are still useful for testing out your ideas and getting a feel for different materials and techniques. Your designs will benefit greatly from practice on an old shirt, glass jar, chipped flower pot, worn wallet, or shabby sneakers.

Once you've exhausted the surface decorating options available in your home it's time to look elsewhere. Michaels and other craft stores have a huge variety of items in assorted shapes and sizes to choose from that are waiting on the shelf to be personalized with your handiwork.

Decorating items that are costly can be intimidating, so look for less expensive items and even bulk items when possible to give multiple opportunities for experimentation and decoration. Dollar and discount stores can be an amazing resource as well. When selecting your item, it's good to take the finish into consideration as inks will adhere best to matte surfaces.

## OPTIONAL SUPPLIES

These are some additional items that are helpful to have but are not absolutely necessary.

- **Baking sheet:** Many of the projects go in the oven for brief periods of time to prolong the life of your artwork. A baking sheet can be used for putting multiple objects in the oven. It's also handy in case your object falls over or is small and doesn't balance well on the oven rack.
- **Cardboard:** Most projects in this book recommend the use of cardboard. It can be placed underneath your project to keep your work surface ink free, or you can cut out a piece to fit inside a T-shirt or tote bag to give it structure while you apply your decoration and to keep the ink from bleeding through.
- **Clothes dryer:** Useful for heat sealing projects on fabric after they are completed, clothes dryers are an alternative to heat sealing with a hot iron.
- **Contact paper:** Contact paper can be used to create your own custom shapes. It also works well for masking areas when you are applying a clear spray finish.
- **Cotton balls, cotton swabs, and paper towels:** These are great for general cleaning and applying rubbing alcohol or paint/varnish to targeted areas.

- **Disposable gloves:** Gloves can be worn to keep your hands clean and prevent your skin from coming into contact with harsh chemicals.
- **Fine grit sandpaper:** If you are prepping a surface for spray painting, a light sanding is usually needed in order to get the best results as it removes imperfections while creating a more ideal surface for the paint to adhere to. Individual sheets are recommended, as opposed to sanding blocks, as they are easier to use to get around curves and into tiny areas.
- **Hot iron:** Most fabrics need to be ironed before decorating. A hot iron can also be used for heat sealing your art after it is completed.
- **Masking tape, rubber bands, stickers, and stencils:** Tape, rubber bands, stickers, and stencils can provide a great guide if you prefer not to hand letter or need help drawing straight lines. Guides are helpful but they are not perfect. Some additional clean up may be needed once guides are removed.
- **Nail polish and toe separators:** For any mani-pedi themed Sharpie art, these tools are essential.
- **Oven:** Many of the ceramic projects need some time in the oven to create a more durable finish. (**Note:** Do *not* preheat the oven when heat sealing art. Place the object into a cold oven and allow it to warm and cool gradually to prevent cracking.)
- **Paint and varnish remover**: When you need to remove oil-based decoration from surfaces there are many brands to choose from, including options that are eco-friendlier with less odor, making them more pleasant to use.
  - As always, use paint and varnish removers sparingly, and take care as they are extremely flammable, and are toxic to skin and lungs.
  - Protect yourself from inhalation of fumes by keeping windows open when working with paint and varnish remover. A window fan can also help to clear vapors from the air more quickly.
  - Use cotton swabs or gloves to keep the solvent from making contact with your skin.
- **Pencil and paper:** Sketch your design before applying it to the surface you are decorating. With some projects it's possible to lightly sketch your design directly onto the surface, or you can use a piece of paper.
- **Plastic trash bag or tarp:** Handy to have for projects that use a wet technique or as a drop cloth when spray painting.

- **Rubbing alcohol:** It's great to have rubbing alcohol for cleaning surfaces (to prepare them before beginning your project) and removing sticky labels or unwanted marks from certain surfaces that have been decorated with permanent markers. (**Note:** All techniques using rubbing alcohol in this book were created using 70% rubbing alcohol.)

- **Rulers:** Rulers are useful for measuring out spacing or as a guide for straight or curved lines.

- **Scissors:** Scissors come in handy for cutting cardboard to fit individual projects.

- **Spray bottle:** Fill a spray bottle with rubbing alcohol for cleaning surfaces and erasing large areas of unwanted markings. (**Note:** It is recommended to label your spray bottle with an oil-based Sharpie. Someone expecting a spritz of water will be in for quite a surprise if they get a spritz of rubbing alcohol instead.)

- **Spray paint and clear coat:** Using spray paint or applying a protective clear coat are listed as optional steps for many exercises to prolong the life of your artwork. Remember to always follow the manufacturer's instructions on the can. If you live in a colder climate, wait to spray your artwork until the warmer months, as a well-ventilated area is needed for spraying. There are a variety of sprays to choose from, so select the one that is compatible with the materials used in your project.

### GENERAL TIPS

Be patient. Allow the ink to dry thoroughly, both between steps and as you draw. If you are the sort that doesn't like to wait, have multiple projects going at the same time so you can work on one project while another is drying. To help prevent smudges, start at the top of your project and work your way down. If you are right handed, working from left to right helps to prevent smears; if you are left handed, working from left to right will work best. When confirming that a project is dry, tap it lightly in several areas before touching the entire surface.

Having trouble getting started? Relax, listen to some music, and enjoy a cup of tea or coffee, or even sip a glass of wine. Look around your home and closet. You chose those things because the patterns appealed to you, so they are a great jumping-off point. There are lots of creative crafters like you online and admiring the handiwork of contemporaries is inspiring.

Keep in mind that Sharpies are not food safe, so when decorating items that will be around food apply your decoration outside of the "active" food area. For instance, don't decorate a mug or glass right around the upper rim where a mouth will go, and when decorating a plate keep the center clear and draw the artwork along the outer rim.

Many projects in this book give the option of a spray clear coat to prolong the life of your artwork. Always allow your project to dry thoroughly. Drying times will vary depending on weather conditions. Be sure to work in a well-ventilated area, preferably outside when working

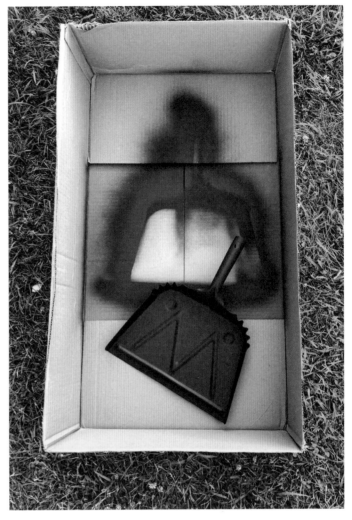

with clear coats and spray paint. Follow the instructions on the spray can closely, and use cardboard or a drop cloth beneath your project to contain it and keep the spray paint from getting on any unintended objects *as shown in the photo. It also doesn't hurt to take a peek at the weather forecast before heading outside with your art and a spray can. Windy days or surprise rain showers are not ideal, and winter months are often too chilly for spray paint to work properly. (**Note**: Depending on the brand you choose, some clear coats can cause your colors to change slightly. If this is a concern, test out the effect on the bottom of your surface or a sample piece to get a feel for how it will interact with your art.)

Some design ideas are included to help you get started. Still having trouble? Stellar drawing skills are not a requirement. A series of dots or dashed lines can be combined to create breathtaking patterns. When drawing more complicated shapes, start with

a simplified shape and add to it. Get more comfortable by practicing your drawing on paper and sampling color combinations before applying art to your chosen item. Decorating surfaces that have raised patterns or indentations is another fantastic way to jump-start your creative process. Adding color to these structural variations can have a huge impact and totally transform the surface! Keep in mind that asymmetrical patterns are far more forgiving than a perfectly spaced and aligned pattern.

Test your markers in an unobtrusive area when experimenting with a new surface. No need to just scribble; why not make the test a design as well so it adds to the decoration *as shown on the reverse side of this belt?

Wash your hands frequently. Wet ink on fingertips or the side of a hand, *as shown in the photo, has smeared many a design; and speaking of washing, take the time to pre-wash and dry the surface that you will be decorating. The ink from the markers will adhere better to a clean surface and will prolong the life of your artwork.

Wrinkles in fabric can complicate any design, so always take the time to iron any fabrics that you will be decorating.

Most importantly, have fun and embrace the imperfect! Yes, mistakes in the design can be removed using a cotton swab and rubbing alcohol or paint/varnish remover, but remember that, unlike something mass produced, you've just created a lovely piece of original artwork, and some wonky lines here and there can add extra charm and warmth.

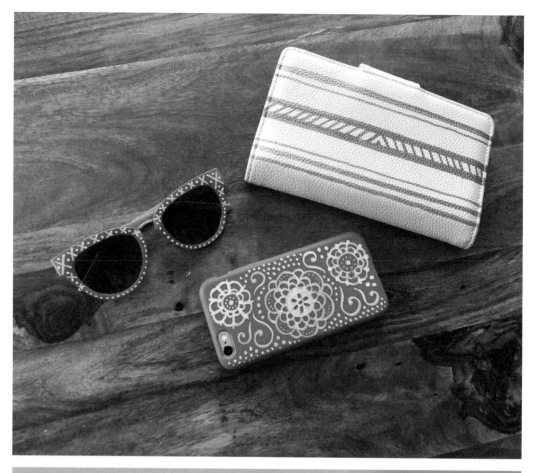

# CHAPTER 2

## CLOTHING AND ACCESSORIES

Add decoration to your personal items to make them as one of a kind as you are.

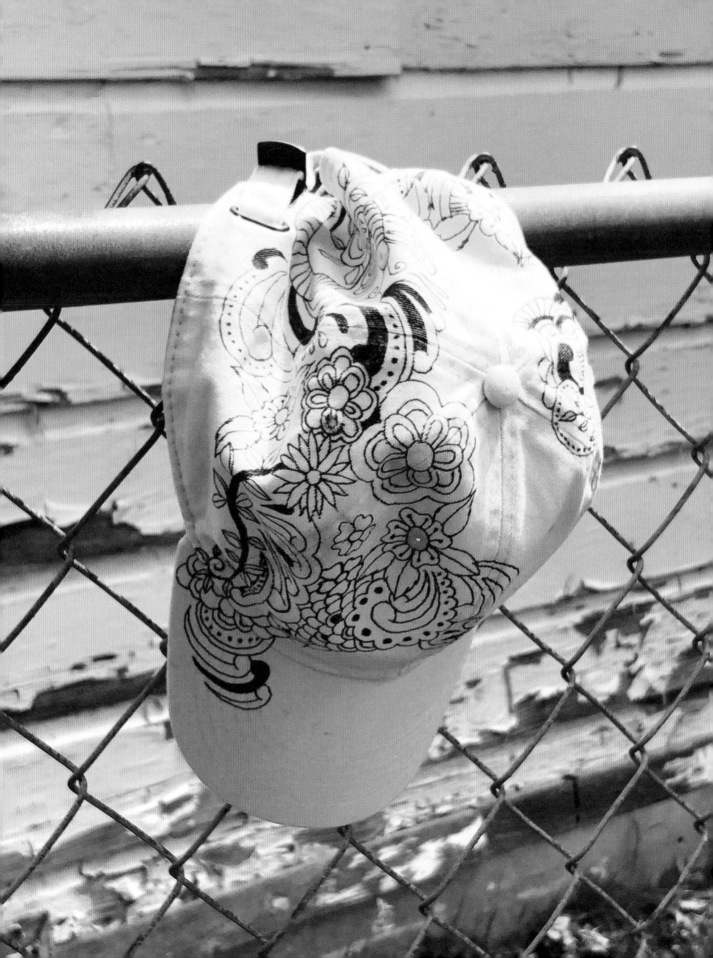

# BASEBALL HATS—STYLISH AND SPORTY

*Liven up a ball cap by adding line art or a surprise pop of color.*

**Supplies:**

- Cotton baseball cap
- Markers—Permanent markers and stain markers work best on a white or light-colored baseball cap. If you are drawing on a dark-colored baseball cap, oil-based markers will work best. (**Note:** Ultra fine permanent markers are recommended for crisp borders and detailed decoration on the rough texture of the canvas cap.)
- Cardboard
- Pencil

**Optional:**

- Dryer
- Support object, such as a bowl or paper

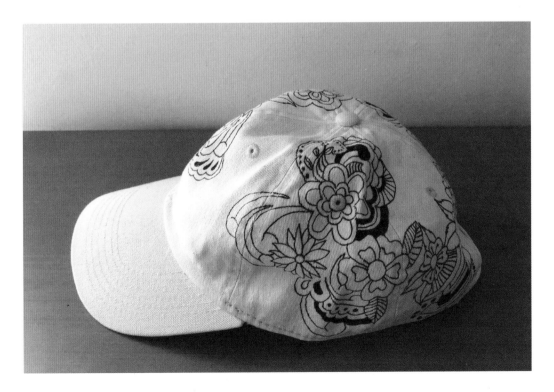

**Step 1**—Use a pencil to lightly sketch your design onto the hat. Keep in mind that the decoration does not have to cover the entire hat. Be mindful of the seams and other characteristics of the hat and take them into consideration when developing your design. For instance, an unexpected pop of color or pattern applied to the underside of the brim is a fun addition. (**Note:** A support object, such as an upside-down bowl or wadded up paper can be placed beneath the cap while you decorate the hat.)

**Step 2**—Test your colors and marks on the inner brim of the hat in an area where the fabric is doubled over to be sure it won't bleed through.

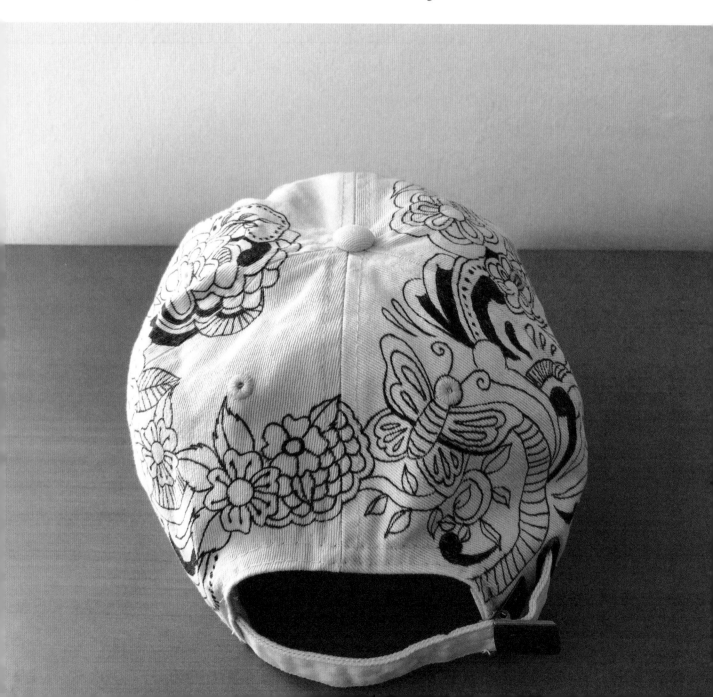

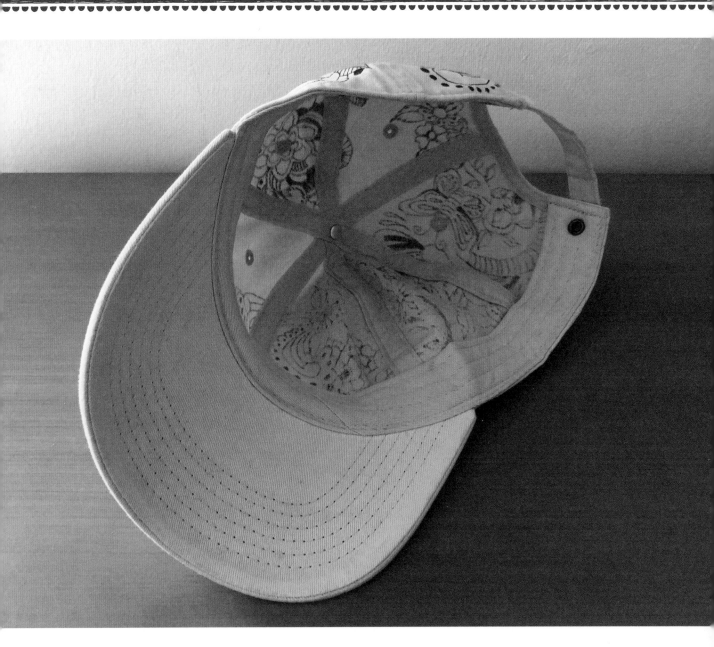

**Step 3**—Place your ball cap on top of a cardboard-protected work surface and apply ultra fine marker to your pencil sketches. To create crisp lines, hold the portion of fabric that you are decorating taut between your thumb and forefinger as you draw. Take your time. Allow areas to dry as you rotate the hat and apply art to the portions that you have chosen to decorate.

**Step 4**—Once the ball cap is completely dry, place it in the dryer on a warm setting for 10 to 20 minutes to heat set your art.

**Step 5**—Enjoy looking like a baller in your new cap!

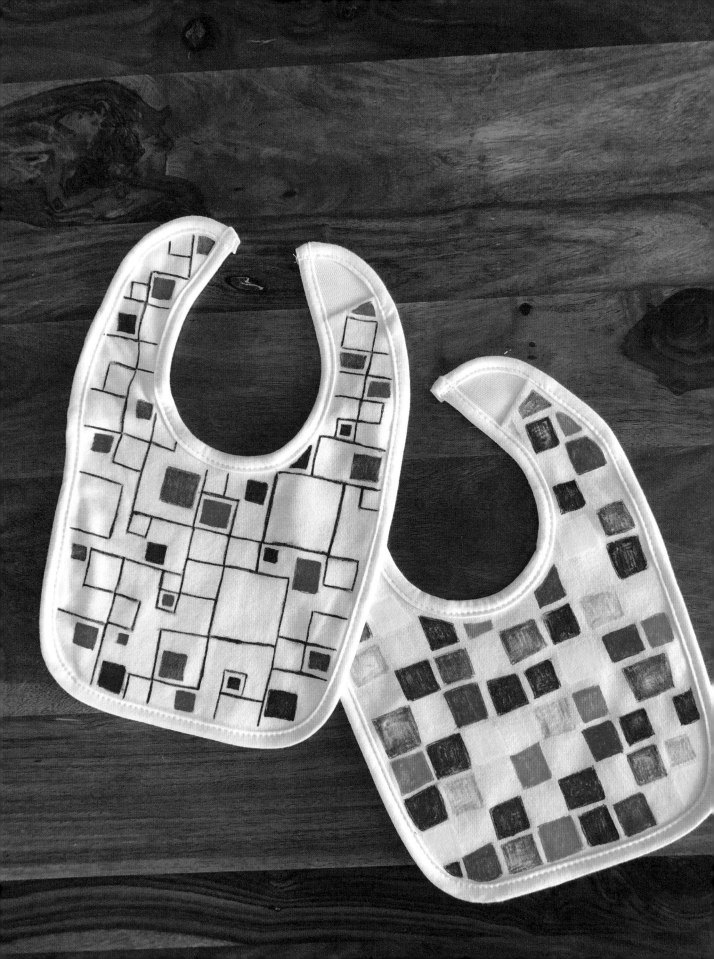

# BIBS—BLOCKY BABY BIBS

*These can be easily made by hand or purchased. Bulk packs are recommended as they give more opportunity for experimentation, and there is no such thing as too many bibs when small children are around.*

**Supplies:**

- Stain or permanent markers in a variety of colors
- Bibs
- Cardboard to place beneath your project as you draw
- Pencil and paper

**Step 1**—Sketch out some designs on paper. Play around with different color combinations, ideally on a spare bib or scrap of similar fabric. Keep in mind that bibs are made to get dirty, so this is a great opportunity to focus on experimentation and fun, not perfection. Colors can be blended by layering them. If you don't want colors to blend, allow individual colors a few moments to set before applying the next color.

**Step 2**—Place your bib on top of a cardboard-covered work surface and apply your design to the bib. Many bib fabrics are a cotton jersey type material and have some stretch. Holding it taut between your thumb and forefinger as you draw can help ensure that your art has a crisper appearance. Take your time. Give inks time to dry as you go so your artwork does not get smeared.

**Step 3**—Heat set the bib in the dryer or with a hot iron before using. Care for your bib by washing in cold water in a delicates bag and line drying for best results.

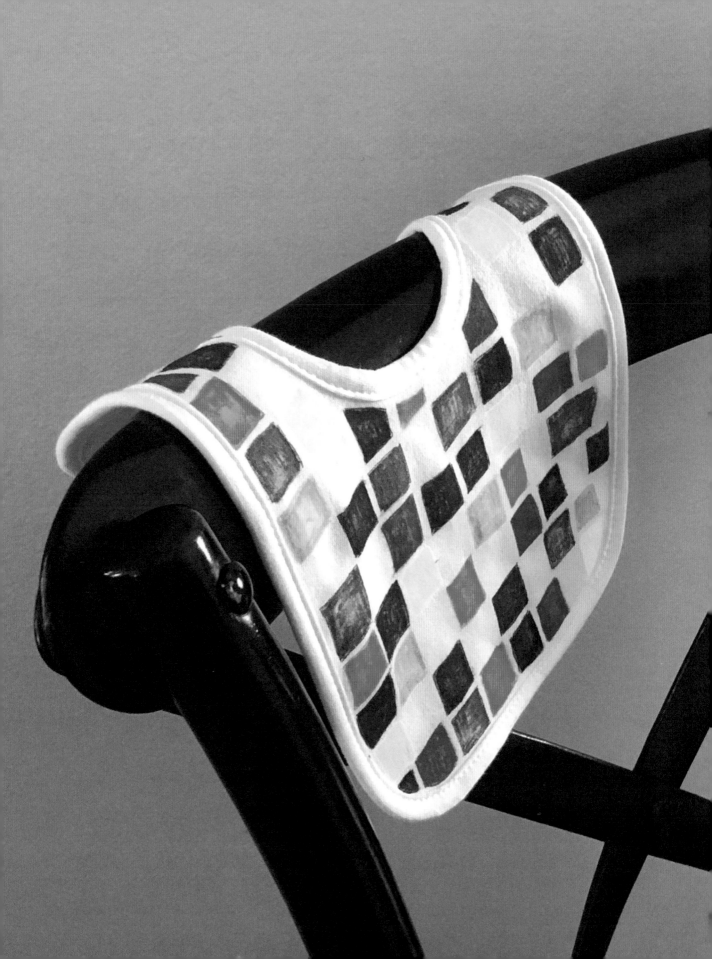

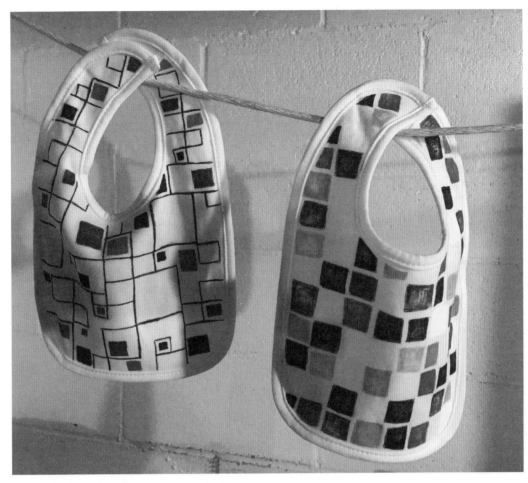

**If working with a bib that has a Velcro or snap neck closure, make sure these bits are unfastened to create a flat surface for drawing on.**

**TIP:** Want to create more items for the wee one in your life? Try creating onesies as well. It's just like creating a bib but make sure to place a piece of cardboard inside the onesie as you draw to provide support and keep the ink from bleeding through to the other side.

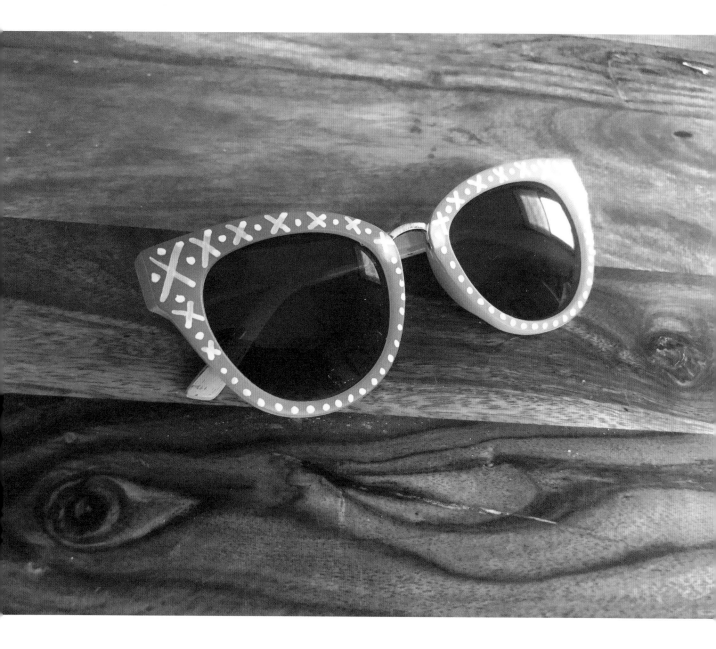

# EYEGLASSES OR SUNGLASSES—SHOWSTOPPER SPECS

*Why spend money on a new pair of sunglasses when you can revamp your old pair with some sassy decoration?*

**Supplies:**

- Glasses or sunglasses—Oversized, plastic frames with a matte finish work best
- Oil-based Sharpies in a variety of colors and tips
- Contact paper
- Scissors
- Rubbing alcohol and cotton balls
- Pencil and paper for sketching

**Optional:**

- Spray clear coat

**Step 1**—Clean the frames or your sunglasses with rubbing alcohol and allow them to dry. Make sure to pay extra attention to the bridge of the nose and portions that wrap around the ears.

**Step 2**—Sketch out any designs that would fit well on the shape of your frames and sample colors. In addition to decorating the outer portion of the frame, be sure to also consider the inner portion. A cheery pop color is an especially fun addition to this area.

**Step 3**—Cut out contact paper to match the shape of the front and back of each lens and apply gently, pressing from the center outward to prevent air bubbles. This step is really a life saver. The contact paper will protect your lenses from scratches as you manipulate the frames to apply the artwork and keep them clear of paint and clear coating.

**Step 4**—Apply your design to the inner and outer parts of the frame. Take breaks to allow sections to dry before progressing to other areas. Take extra care around the screws and the area where the lens and frames meet.

**Step 5**—Once the glasses are thoroughly dry remove the contact paper protecting the lenses. Enjoy strutting around town sporting your stylish new specs!

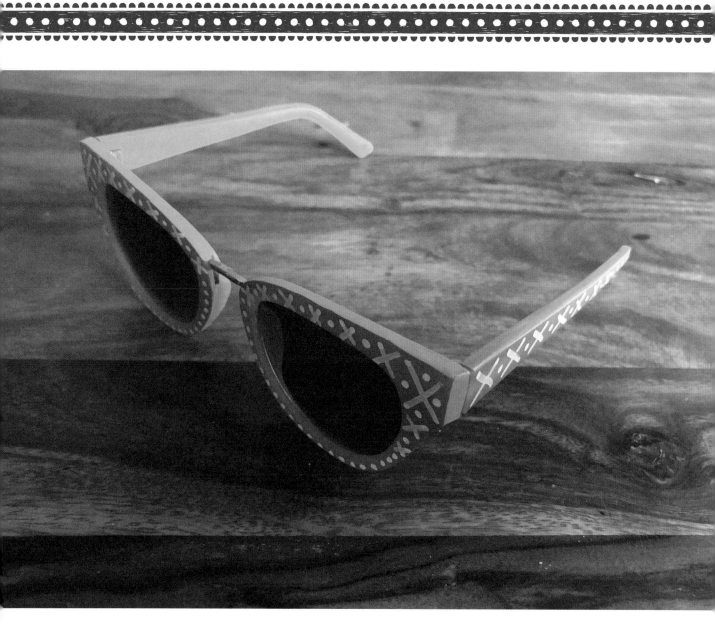

**TIP:** Having trouble duplicating the exact shape of the lens? Hold a spare piece paper against the lens (tissue or newsprint paper work especially well for this) and gently press your fingernail along the edge where the lens and frame meet. Cut along the indentation and then use this as a guide to trace onto your contact paper.

**Optional:** Give your completed glasses several hours to dry or, even better, let it set overnight before spraying it with a clear coat. Before applying a light clear coat press firmly around the edges of the contact paper, coating the lenses to make sure it is sealed. If needed, apply some masking tape to any areas of the lens that may be exposed. Follow the instructions on the spray can closely. Make sure to spray paint in a well-ventilated area, preferably outside, and use a cardboard box or drop cloth to contain the glasses and keep the spray from getting on any unintended objects.

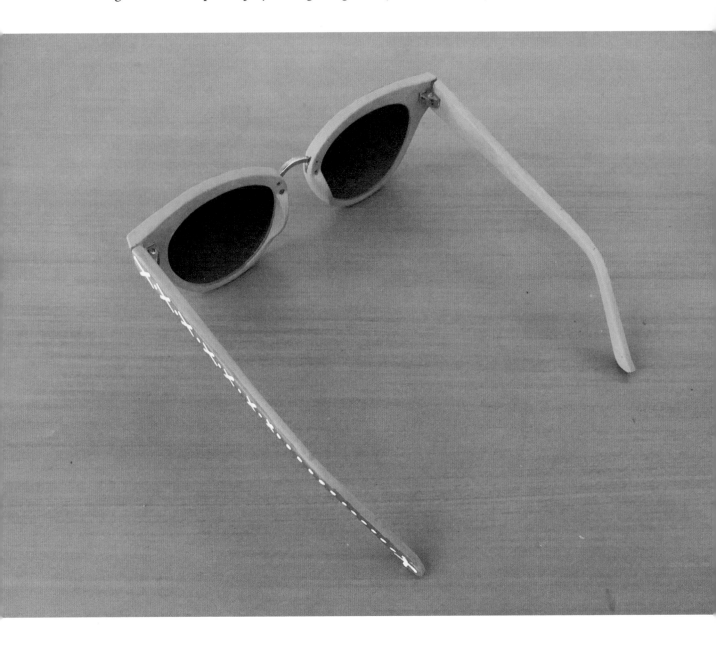

# JEWELRY—BAUBLES WITH BLING

*Simple steps to give stale jewelry a fresh look.*

**Supplies:**

- Clear rhinestone jewelry
- Permanent markers—Those with fine and ultra fine tips work best, especially for decorating the very small stones
- Cardboard
- Rubbing alcohol
- Cotton swabs

**Optional:**

- Spray clear coat
- Masking tape
- Oil-based Sharpies

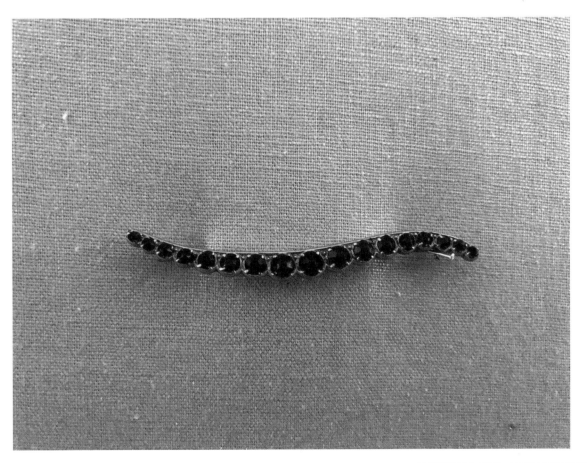

**Step 1**—Use cotton swabs to clean each rhinestone and allow them to dry thoroughly.

**Step 2**—Place your jewelry on a cardboard-protected work surface and carefully apply your selected colors to each stone. Rubbing alcohol can be used to remove the color or dabbed very gently to lighten it. Consider using masking tape to secure your item to the cardboard if you are having trouble manipulating it. This is especially handy for necklaces.

**Step 3**—Wait until the piece is thoroughly dry before donning your new bling.

**Optional:** A lot of skincare products come into contact with jewelry, such as perfume, lotion, and makeup. If you want to prolong the life of your new bling, protect it with a clear spray coat. Give your completed bauble several hours to dry or, even better, let it set overnight before spraying it with a clear coat. Follow the instructions on the spray can closely. Make sure to spray paint in a well-ventilated area, preferably outside, using a cardboard box or drop cloth to contain the jewelry and keep the spray from getting on any unintended objects.

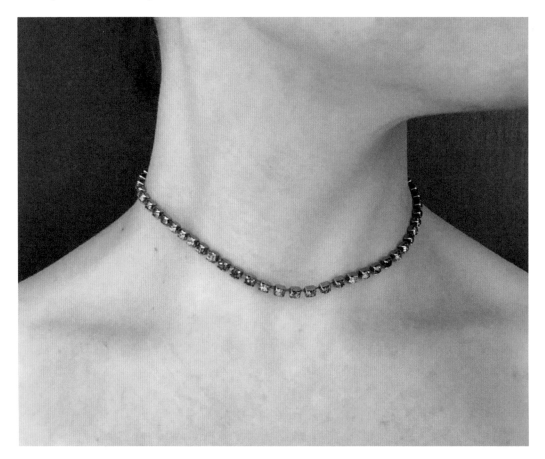

**TIP:** You can achieve many different looks using this technique, from neon to bright rainbow hues or black bling for a more subtle look. Try using oil-based markers for a completely different opaque appearance.

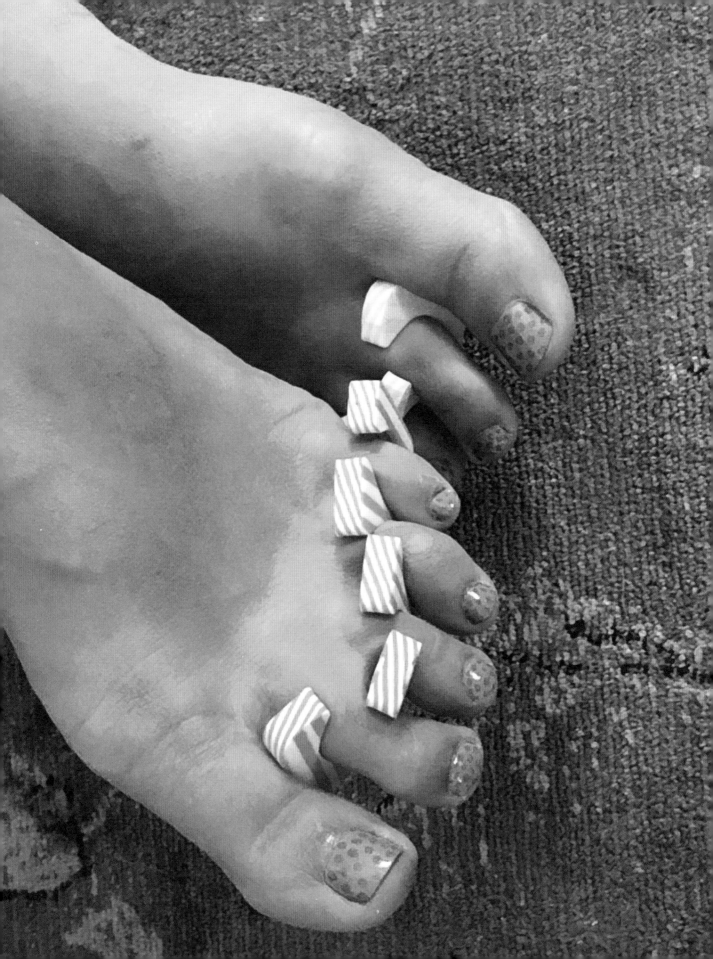

# NAIL ART—TOTALLY ADORABLE TOES (OR FINGERS)

*Punch up your mani or pedi by adding marker decoration.*

**Supplies:**

- Nail polish in a color of your choosing
- Oil-based paint markers—The fine size works best as the tiny tip on the ultra fine markers tends to gouge at the polish when applied
- Cardboard

**Optional:**

- Toe separator

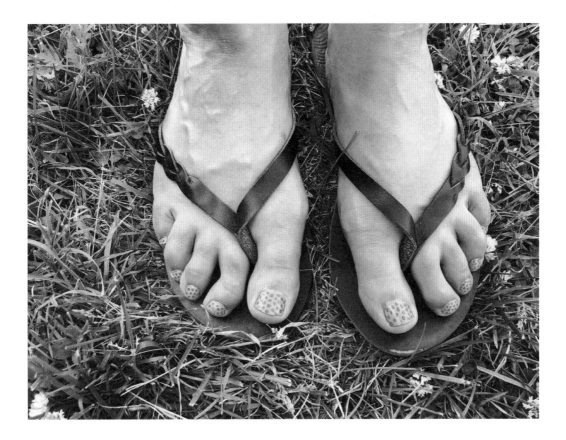

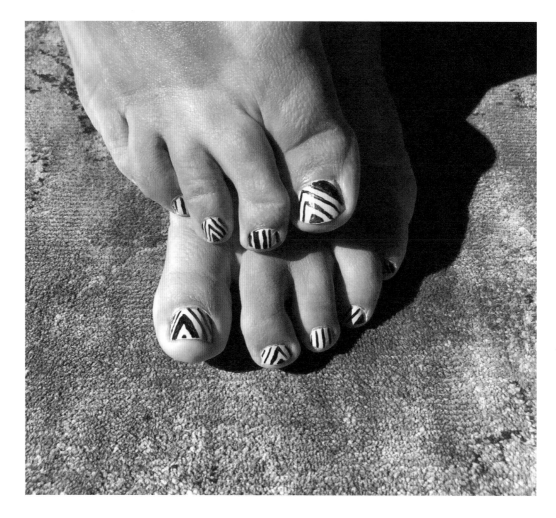

**Step 1**—Prepare the surface of your nails with your usual mani or pedi treatment in your selected color and allow to thoroughly dry.

**Step 2**—Apply a clear top coat to your mani or pedi as usual and allow to dry for several hours.

**Step 3**—Once your polish is dry, place your hand or foot over a piece of cardboard or scrap paper and apply patterns as desired. Designs can be applied to every nail or just to a few, and there is no need to repeat the same pattern on every nail. Starting with feet is great practice, as hands get a little more complicated unless you are ambidextrous. Use a toe separator if applying polish to toes. (**Note:** *Do not apply a clear coat over the markers*. The chemicals in the clear coat cause the ink colors to bleed.)

**Step 4**—Enjoy your custom look, and when it's grown out or chipped you can remove with nail polish remover as usual and try out a new design!

Want some practice before applying a design to your own nails? Prepare a practice surface by painting some polish onto a plastic object that is easy to manipulate. Plastic works best for the test surface because the polish doesn't get absorbed and will provide a finish most like the finish on your nails.

**TIP:** This treatment can also be a great way to extend the life of an existing mani or pedi by covering up chipped areas, and it's a fun project to work on with a friend. Why not have a Sharpie nail party?!

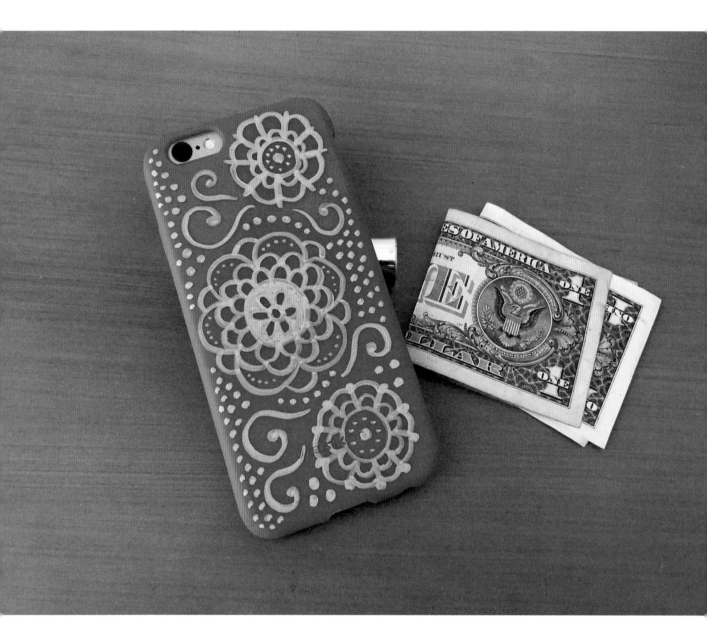

# PHONE CASES—PERSONALIZED PHONE CASE

*Add your own flair and style to one of your most personal objects.*

**Supplies:**

- Silicone phone case that is appropriately sized for your phone
- Oil-based Sharpies in a variety of shapes and colors
- Pencil and paper
- Cardboard
- Rubbing alcohol

**Optional:**

- Clear spray coat in a finish of your choosing

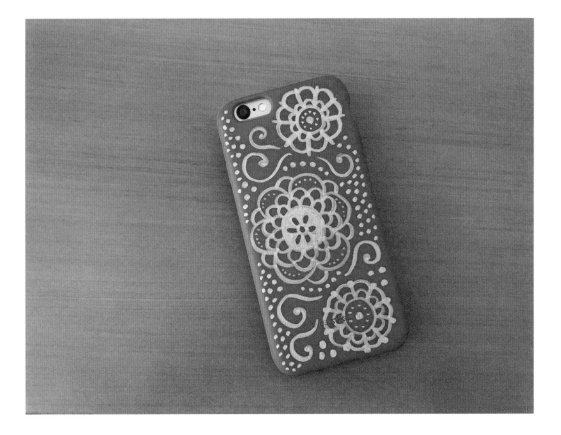

**Step 1**—Clean the phone case with rubbing alcohol and allow it to dry thoroughly.

**Step 2**—Use a pencil and paper to trace your phone case to create a full-sized mock up for your sketches. You may also want to create a design for the inside. It can be a great way to add a fun or secret motivational message for yourself and also a wonderful opportunity to get a feel for working on the silicone surface before decorating the visible portion of the phone case.

**Step 3**—Place the phone case on your cardboard-covered work surface. Apply the design to the inside of the phone case and allow it to dry thoroughly. *As shown in the sample photos, letter shaped stickers can be a great shortcut to creating silhouetted letters. Take your time when applying stickers and place them gently to allow for repositioning as needed. Once they are lined up and spaced evenly press firmly to secure them and then decorate around the letters with your markers.

**Step 4**—Once the inside of the case is thoroughly dry, apply the design to the outside of the case.

**Step 5**—Pop the dry and decorated case onto your phone. Ta-da!!!

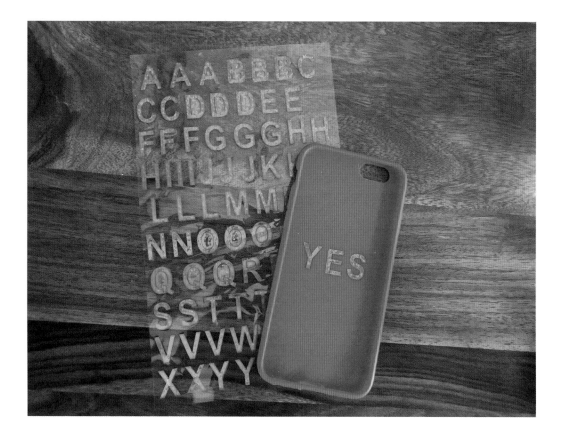

**Optional:** If you want to lengthen the life of your new phone case protect it with a clear spray coat. Give your completed case several hours to dry or, even better, let it set overnight before spraying it with a clear coat. Follow the instructions on the spray can closely. Make sure to spray paint in a well-ventilated area, preferably outside, and use a cardboard box or drop cloth to contain the case and keep the spray from getting on any unintended objects.

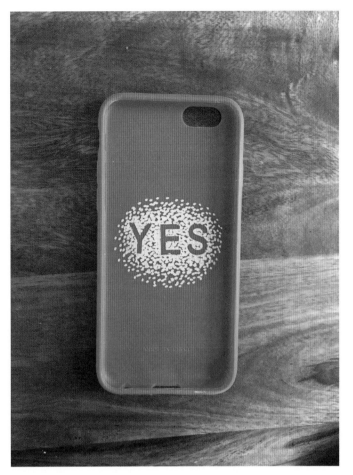

**TIP:** A fun variation on this project is to decorate a clear phone case on the inside only. That way you can create a sketch and trace right over it instead of free-handing. Just keep in mind that because you are drawing on the inner portion any lettering will need to be reversed.

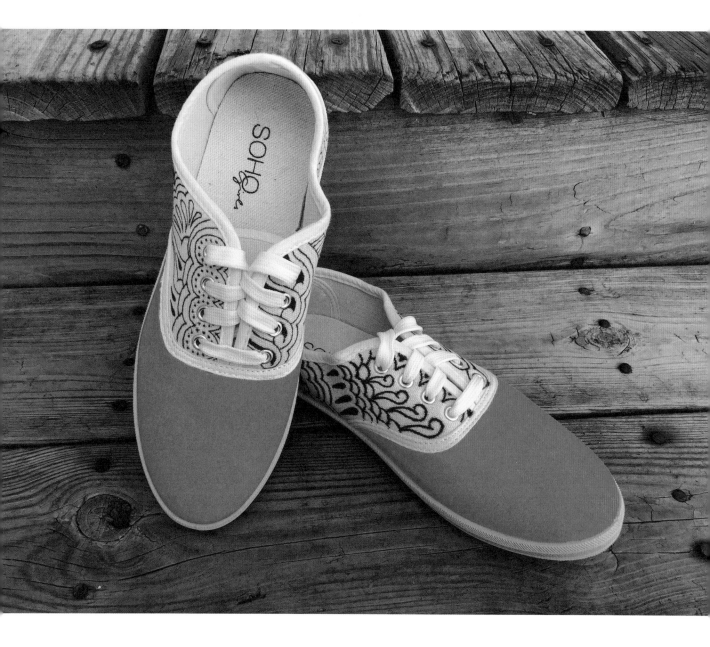

# SNEAKERS—FANCY FEET

*Give a plain pair of sneakers a kick by adding line art and bold colors.*

**Supplies:**

- Canvas sneakers
- Markers—Permanent markers and stain markers work best on white or light-colored sneakers. If you are drawing on dark-colored sneakers, oil-based markers will work best
- Cardboard
- Pencil

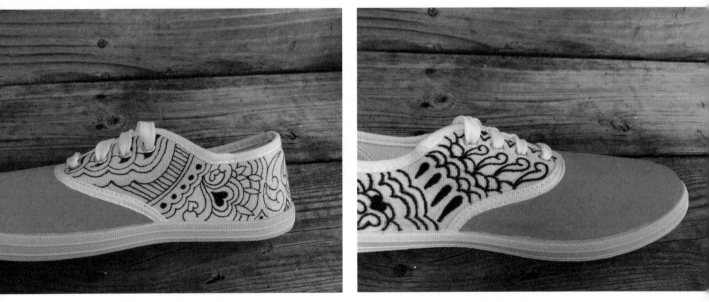

Ultra fine permanent markers are recommended for crisp borders and detailed decoration on the rough texture of the canvas. You can see the difference in the photos: the black and white artwork was applied to the shoe on the left using a marker with an ultra fine tip and the black and white artwork shoe on the right was drawn using a marker with a fine tip. Stain markers work well for saturated color blocked areas such as the pink toe area in the photos.

**Optional:**

- Dryer
- Paper

**Step 1**—Remove the laces from the sneakers and lightly sketch your design directly onto the shoe. If you need support inside the shoe as you decorate it, place your hand inside it or use some wadded-up paper. (**Note:** Keep in mind that the decoration does not need to be the same on each shoe.)

**Step 2**—Place your shoes on top of a cardboard-covered work surface and test colors on the liner along the footbed of the shoe, if desired.

**Step 3**—Use an ultra fine marker to outline your sketches and color in areas once the line art is completed. If applying color blocking, alternate between shoes as you apply multiple layers to achieve a rich, saturated color.

**Step 4**—Allow the shoes to dry thoroughly before lacing them up and donning your crafty kicks.

**Optional:** To heat set the artwork on the sneakers place them in your dryer set to warm for 10 to 20 minutes.

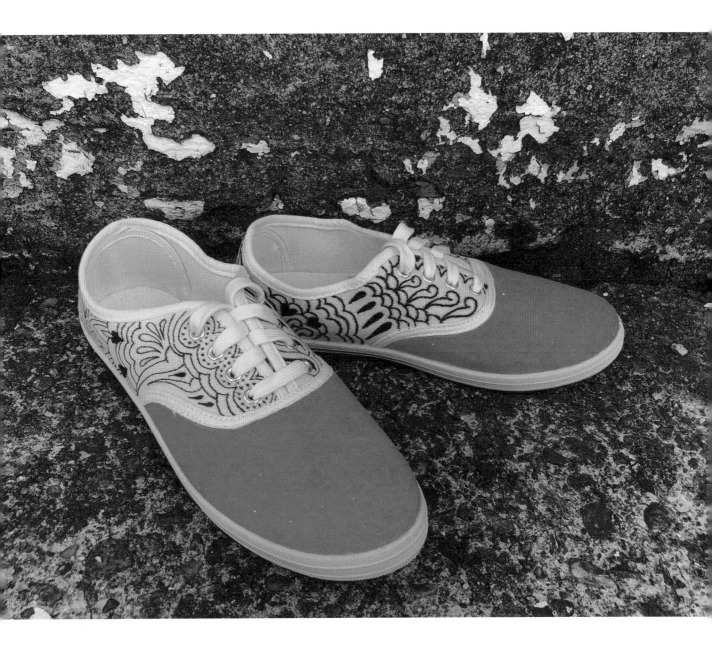

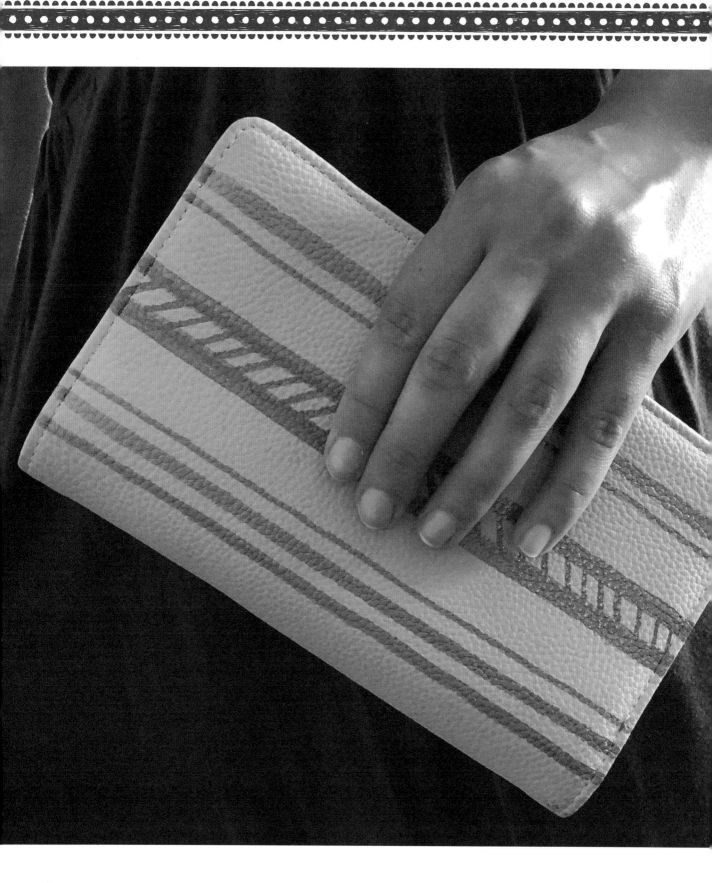

# WALLETS/CLUTCHES—ART WORTH HOLDING ON TO

*Don't want to spend a lot on a new wallet? Spruce up one that you already have.*

**Supplies:**

- Leather wallet or clutch—An untreated, matte leather will work best
- Oil-based Sharpies in a variety of sizes and colors
- Cardboard
- Pencil and paper

**Optional:**

- Masking tape

Step 1—Clean the clutch and allow it to dry thoroughly.

Step 2—Sketch some designs on paper or directly onto the clutch, if desired. (**Note:** If using tape to mask areas, apply it in the design of your choosing.)

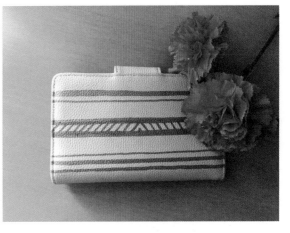

Step 3—Place the clutch on top of a cardboard-protected work surface and apply the decoration. If decorating both sides allow the first side to dry thoroughly before flipping the clutch to decorate the opposite side. (**Note:** If tape was applied, wait for the paint to dry completely before removing it and cleaning up any untidy edges.)

Step 4—Enjoy your one-of-a-kind clutch!

**TIP:** This technique can be used on just about any leather object. Why not revitalize an old belt, pair of boots, or leather jacket?

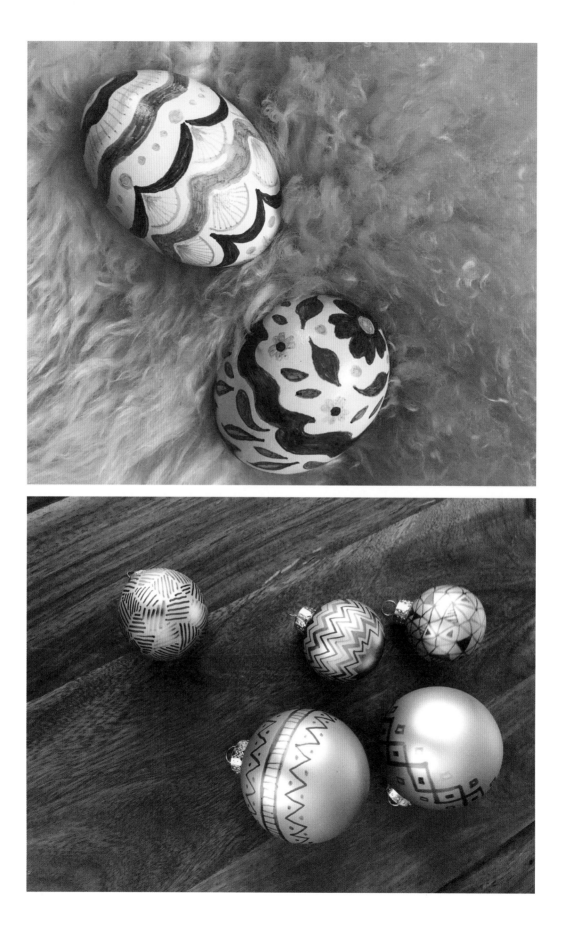

# CHAPTER 3

# HOLIDAYS

Save on mess by enhancing your holiday decorations
with Sharpies instead of dyes, glue, and pumpkin goo

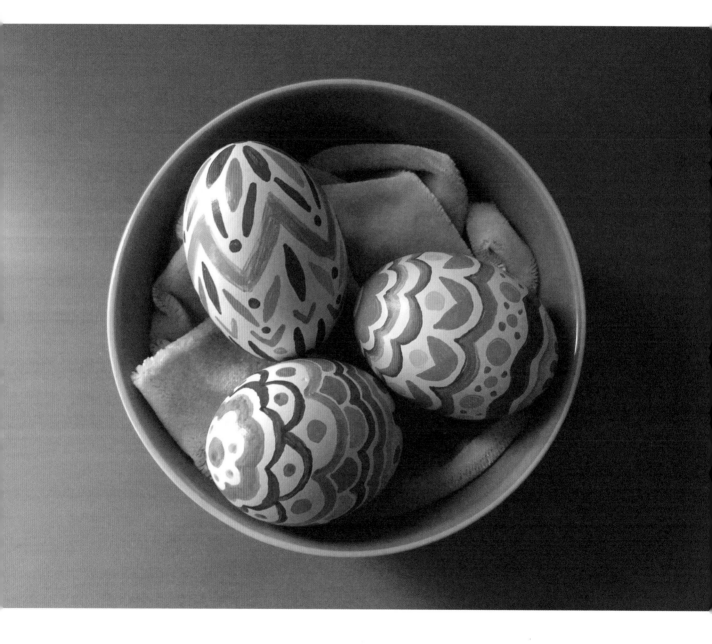

# EASTER EGGS—EXTRA-SPECIAL EGGS

*Skip the dye kit and decorate your eggs your delightful drawings this year!*

**Supplies:**

- Faux eggs—Usually these are wooden with a coat of white paint, but other colors can be purchased. Bulk sets are recommended, it's lovely to have a spare egg or two just for testing out design ideas and techniques
- Markers—Permanent markers in a variety of sizes and colors work well on a white egg to achieve a similar look to dip dyed eggs or use, oil-based Sharpies for a more opaque look. (**Note:** If working with a darker colored egg, oil-based Sharpies work best.)
- Egg crate or other support object, such as an egg cup, small bowl, or jar
- Pencil
- Cardboard

**Optional:**

- Rubbing alcohol if you're working with permanent markers. (**Note:** Use sparingly so as to not damage the finish on the faux egg.)
- Paint/varnish remover if you're working with oil-based pens. (**Note:** Use sparingly so as to not damage the finish on the faux egg.)
- Cotton swabs
- Spray clear coat

**TIP:** If you prefer to use real eggs, the bad news is that hard-boiled eggs just don't work for this technique. The good news is that you can create workable eggs by using a sewing pin to gently poke a hole in each end of a well-cleaned raw egg and gently rotate it around the inner edge of the puncture to enlarge the holes slightly. While holding the egg over a bowl, place your mouth over one hole and blow the contents of the egg out the opposite hole and into the bowl. This can take some time, but as a reward for your efforts you get to have scrambled eggs or some other yummy egg-based dish. If you try this technique, be gentle to prevent cracks and breakage to the shell.

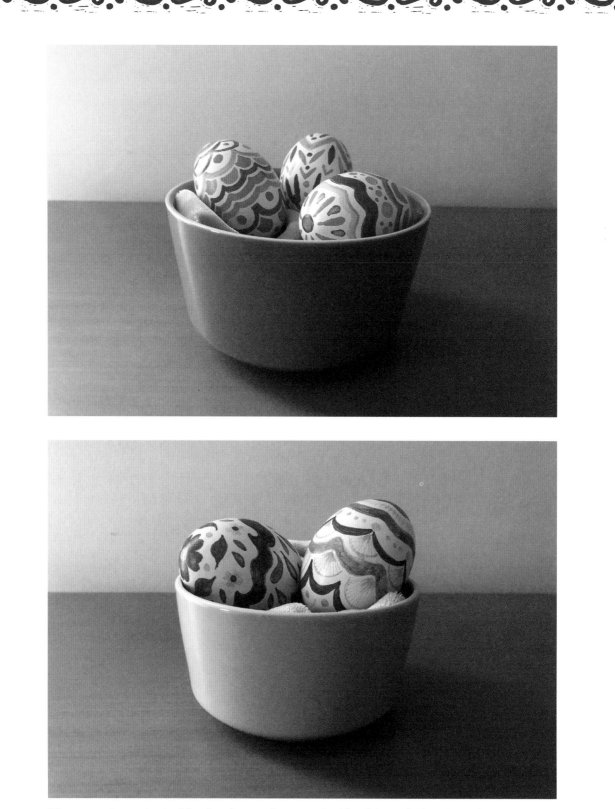

The eggs shown in the blue bowl were decorated with oil-based Sharpies. The eggs in the yellow bowl were decorated using permanent Sharpies.

**Step 1**—Using a pencil, gently sketch your design directly onto the egg.

**Step 2**—Set your egg crate or support object on top of your cardboard-protected work surface. Place your egg on the support object and delicately apply the ink to your design. (**Note:** It's great to work on multiple eggs at the same time so you can alternate between the two as the freshly decorated areas dry.)

**Step 3**—If you want to add a wash or water color effect, dip a cotton swab in a small amount of rubbing alcohol and gently dab it on the desired areas after they have been decorated with permanent marker.

**Step 4**—Set out your new decorations in a basket or bowl and admire your eggsterpiece!

**Optional:** A clear coat can help to preserve your artwork if you like to save your eggs to be displayed year after year. Give your completed drawing several hours to dry or, even better, let it set overnight before spraying it with a clear coat. Follow the instructions on the spray can closely. Make sure to spray paint in a well-ventilated area, preferably outside, and use a cardboard box or drop cloth to contain the eggs and keep the spray paint from getting on any unintended objects. Wait for the top to dry completely before flipping the egg to coat the underside.

**Care Instructions:** Wipe clean with a dry paper towel and feather dust as needed.

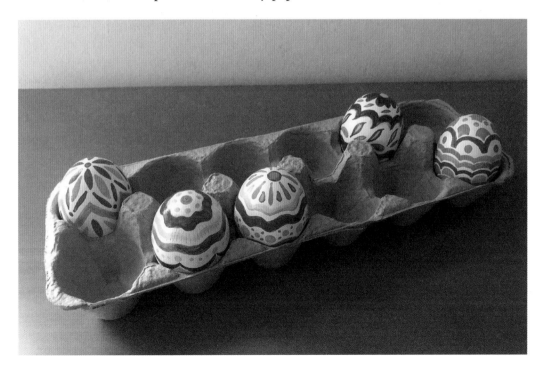

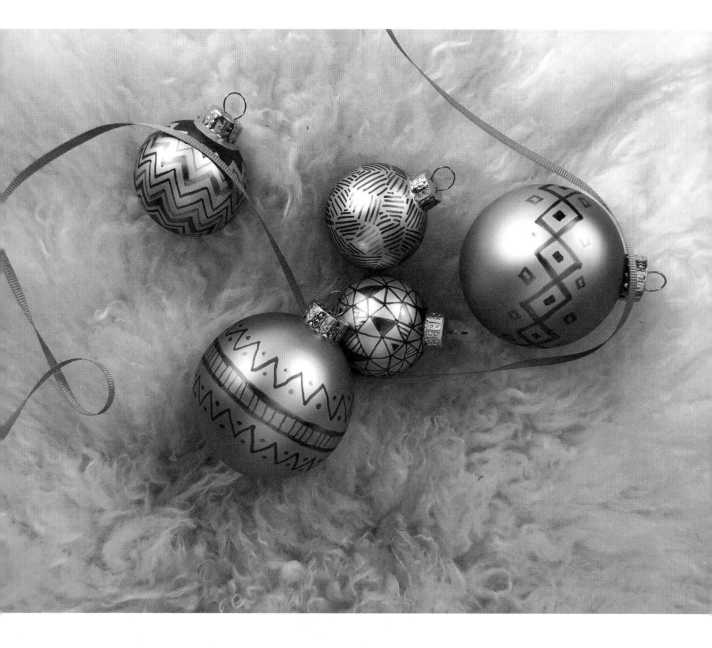

# ORNAMENTS—BEAUTIFUL BAUBLES

*These custom crafts make a lovely and personal keepsake that will be enjoyed on your tree year after year.*

**Supplies:**

- Christmas ornaments—Simple shapes with a matte surface, without glitter or texture work best
- Permanent markers in varying colors and thicknesses
- Paper and pencil
- Cardboard

**Optional:**

- Spray clear coat
- Support object that the ornament can be perched on while drawing to prevent finger smudges in your art—An egg tray, cut down paper towel roll, or small cup work well
- Low tack art tape

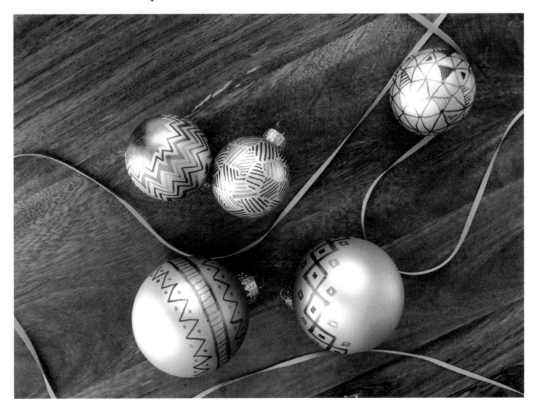

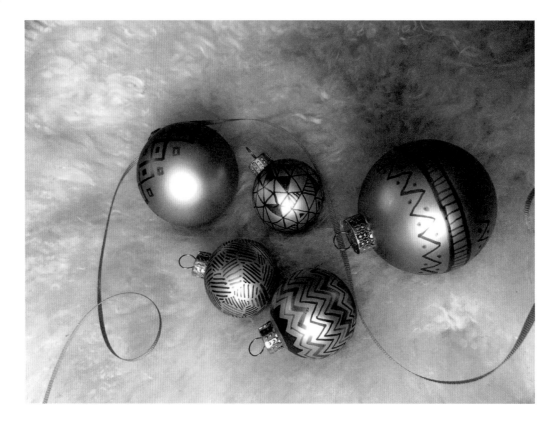

**Step 1**—Practice your design and different color combinations using pencil and paper before applying it to the curved surface of the ornament.

**Step 2**—Now that you've practiced your design, consider what colors would look best on the color of the ornament you are decorating. Experiment with mixing line art with colored areas and cross hatching to create a lively design. (**Note:** A piece of low tack art tape can be applied to the ornament as a guide for creating straight edges without damaging the surface of the ornament.)

**Step 3**—Place your ornament on top of a cardboard-covered work surface. Keep your ornament steady while decorating it using your hand or a support object. Take your time and let the ink dry as you rotate the ornament to avoid smudges.

**Step 4**—Enjoy the added warmth that comes from decorating your home with your own personal designs.

**Optional:** Ornaments can receive a lot of abuse between getting packed, unpacked, and coated with sticky sap every year. A clear coat can be applied to prolong the life of your creation. Give your completed drawing several hours to dry before spraying

it with a clear coat, or, even better, let it set overnight. Follow the instructions on the spray can closely. Make sure to spray paint in a well-ventilated area, preferably outside, and use a cardboard box or drop cloth to contain the ornaments and keep the spray paint from getting on any unintended objects.

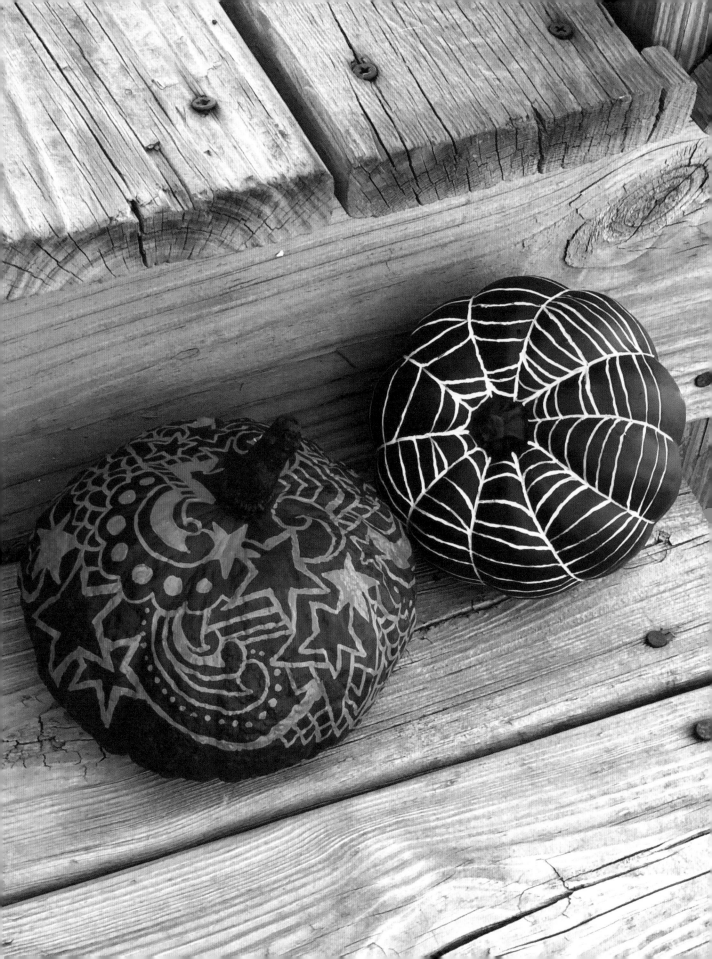

# PUMPKINS—PUMPKINS WITH IMPACT

*Why not draw on your pumpkins and gourds instead of carving them and dealing with gooey guts and slippery sharp tools?*

**Supplies:**

- Pumpkin or gourd—Yes, you can draw directly on the rind of your pumpkin with permanent Sharpies, but it will have more impact if spray painted in the color of your choosing. As a bonus, the spray-painted surface will be easier for sketching out your design
- Spray paint in the color of your choosing—A matte finish works best
- Oil-based Sharpies
- Cardboard
- Pencil

**Optional:**

- Clear spray coat

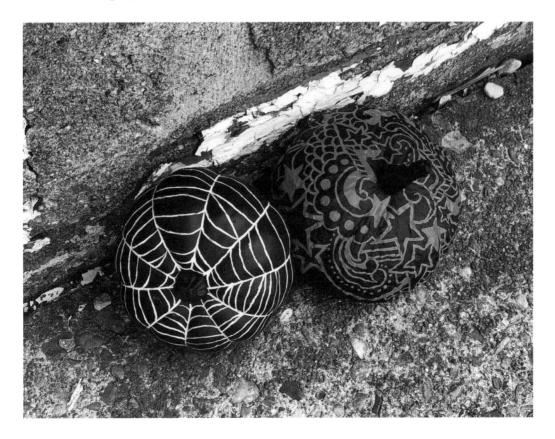

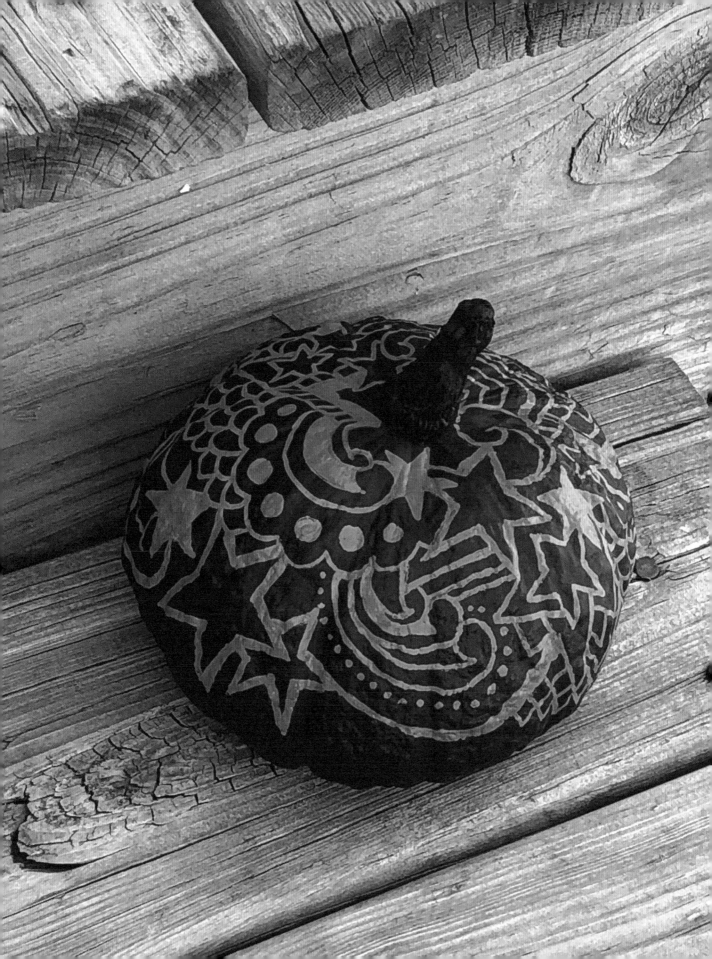

Step 1—Clean your pumpkin and allow it to dry thoroughly.

Step 2—Spray your dry pumpkin with the spray paint that you have selected. Follow the instructions on the spray can closely. Make sure to spray paint in a well-ventilated area, preferably outside, and use a cardboard box or drop cloth to contain the pumpkin and keep the spray paint from getting on any unintended objects. (**Note:** If you want the underside of the pumpkin to be painted as well, wait for the top to dry completely before flipping the pumpkin to coat the underside.)

Step 3—Wait at least a day to allow your painted pumpkin to dry thoroughly before proceeding. Place your painted pumpkin on top of your cardboard-protected work surface and lightly sketch your design on the painted pumpkin. Have fun and don't feel limited to a traditional face, the pumpkin could be decorated with a message or beautiful doodles.

Step 4—Place your showpiece pumpkin out for all to admire!

**Optional:** A clear coat can help to preserve your artwork if your pumpkin will be exposed to the elements. The process is very similar to applying the spray paint. Give your completed drawing several hours to dry or, even better, let it set overnight before spraying it with a clear coat. Follow the instructions on the spray can closely. Make sure to spray paint in a well-ventilated area, preferably outside, and use a cardboard box or drop cloth to contain the pumpkin and keep the spray paint from getting on any unintended objects.

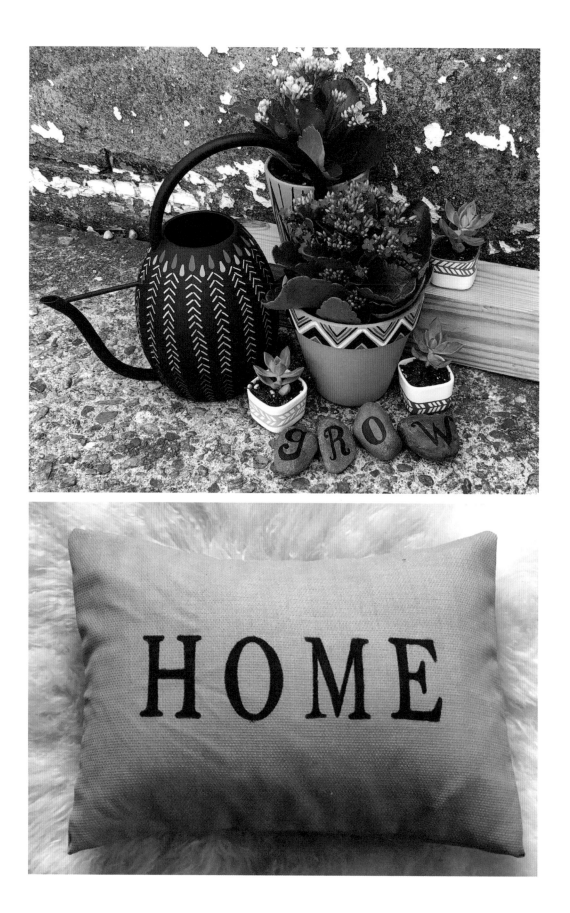

# CHAPTER 4

## HOME DÉCOR AND GARDENING

Sharpie art can have a huge impact on your home. Use it to personalize by adding pops of color or patterns—you'll rejuvenate worn items instantly.

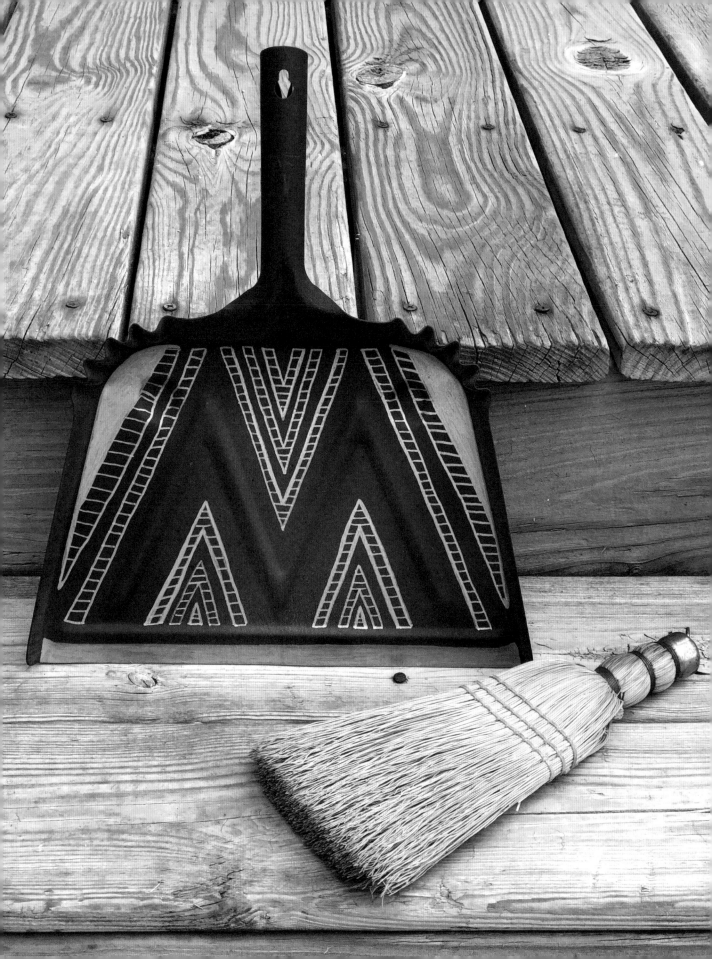

# DUSTPANS—DAZZLING DUST PAN

*Sweeping will seem like less of a chore when you transform your humdrum tools into things of beauty. Turn your dust pan into a showpiece by giving it the Sharpie treatment.*

**Supplies:**

- Dust pan—Metal is recommended
- Oil-based Sharpie markers in a variety of shapes and colors
- Cardboard
- Pencil and paper

**Optional:**

- Masking tape
- Spray paint—A matte finish works best
- Spray paint clear coat in your choice of finish
- Fine grit sandpaper

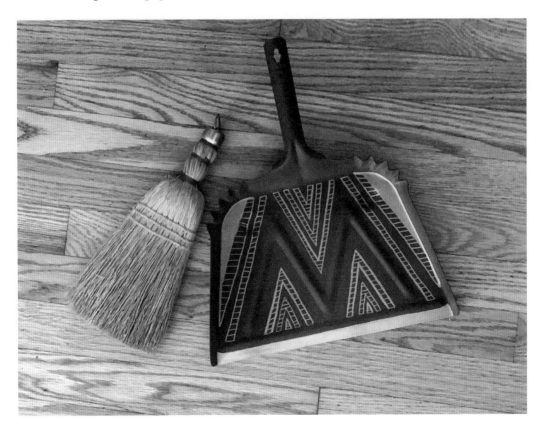

**TIP:** If working with an old, chipped dustpan, lightly sand it with fine grit sandpaper and spray paint it in the color of your choice to prepare the surface. Paint the pan at least a day before beginning your drawing.

Step 1—Prepare your dustpan by cleaning it and spray painting, if necessary.

Step 2—Sketch out your ideas for the dust pan on paper or directly onto the pan if working with a freshly painted pan. Consider the shape and any raised edges or pressed details and how they can be incorporated into your art.

Step 3—Make sure that the dust pan is clean and dry before beginning. If your project requires tape to mask areas and assist in creating straight lines, apply it to the pan before you begin your drawing. Place the pan on top of a cardboard-protected work surface and apply your design. Take time to let each side dry before proceeding to the next to prevent smudging your artwork.

Step 4—Enjoy sweeping up dust bunnies with your spruced-up pan!

**Optional:** Dustpans receive a lot of use and abuse. A clear spray coat will protect your artwork and help it to last longer. Give your completed drawing several hours to dry or, even better, let it set overnight before spraying it with a clear coat. Follow the instructions on the spray can closely. Make sure to spray paint in a well-ventilated area, preferably outside, and use a cardboard box or drop cloth to contain the dust pan and keep the spray paint from getting on any unintended objects.

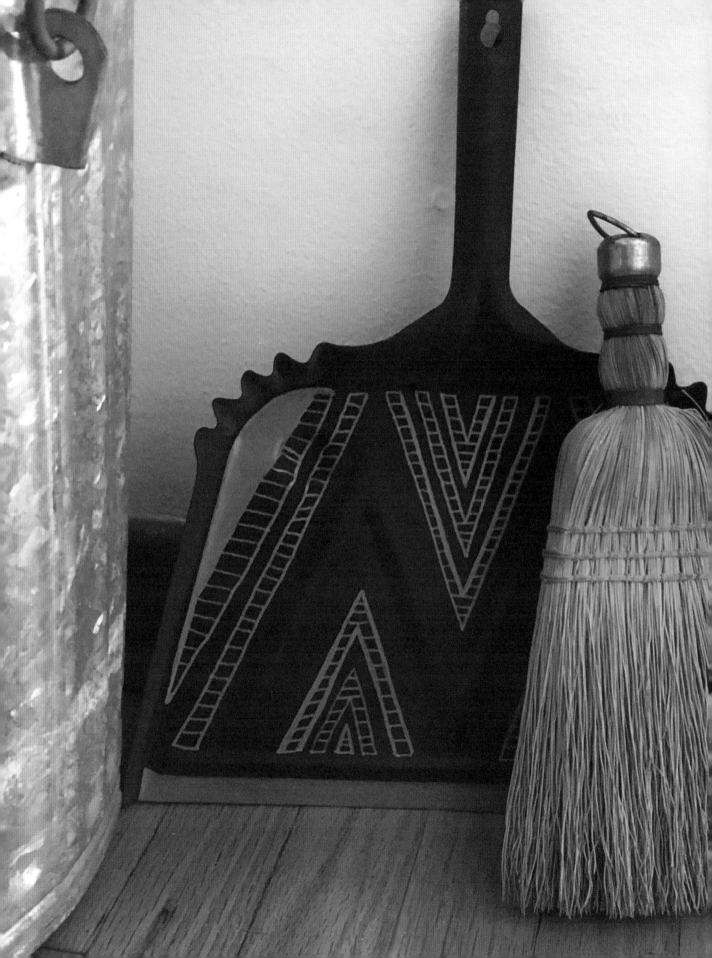

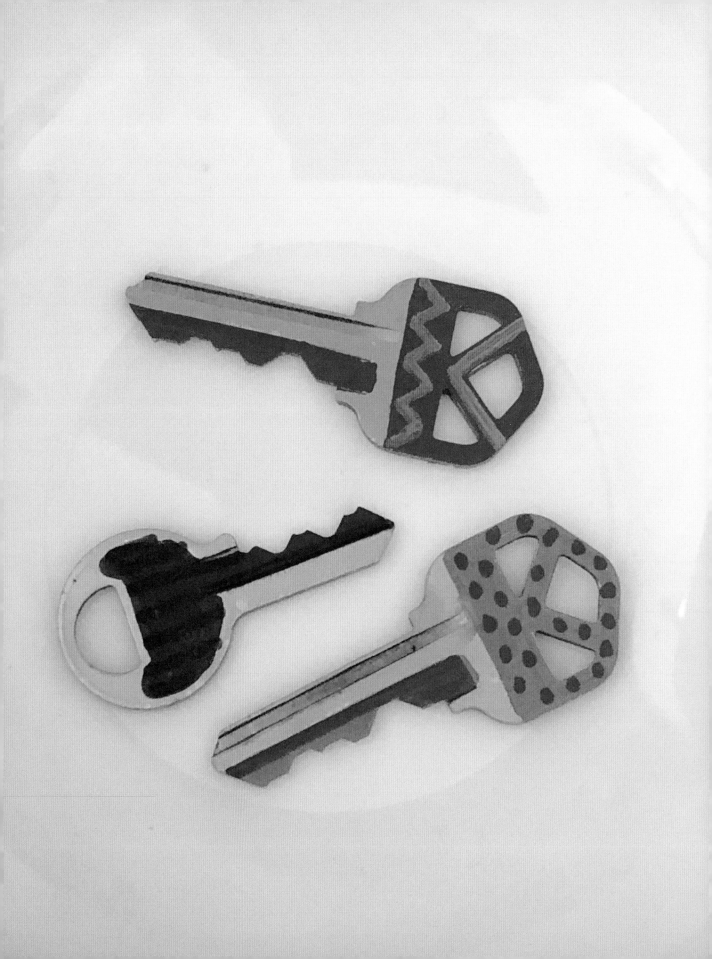

# HOUSE KEYS—KEY OF A DIFFERENT COLOR

*Some projects are small but have a huge impact. If you have multiple keys on your key ring, this project will make a huge difference every time you enter your home.*

**Supplies:**

- Metal keys
- Oil-based Sharpies in a variety of sizes and colors, especially ultra fine tipped markers for detailed decoration
- Pencil and paper
- Cardboard

**Optional:**

- Clear spray coat

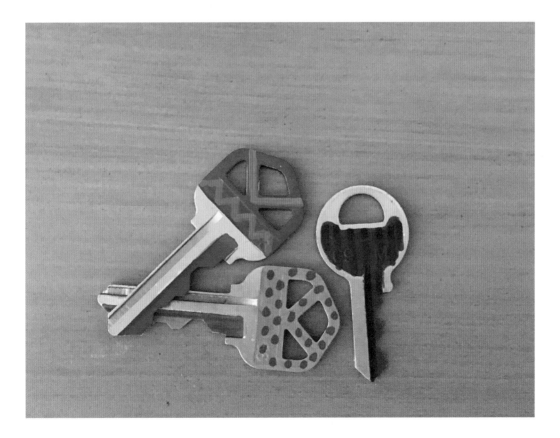

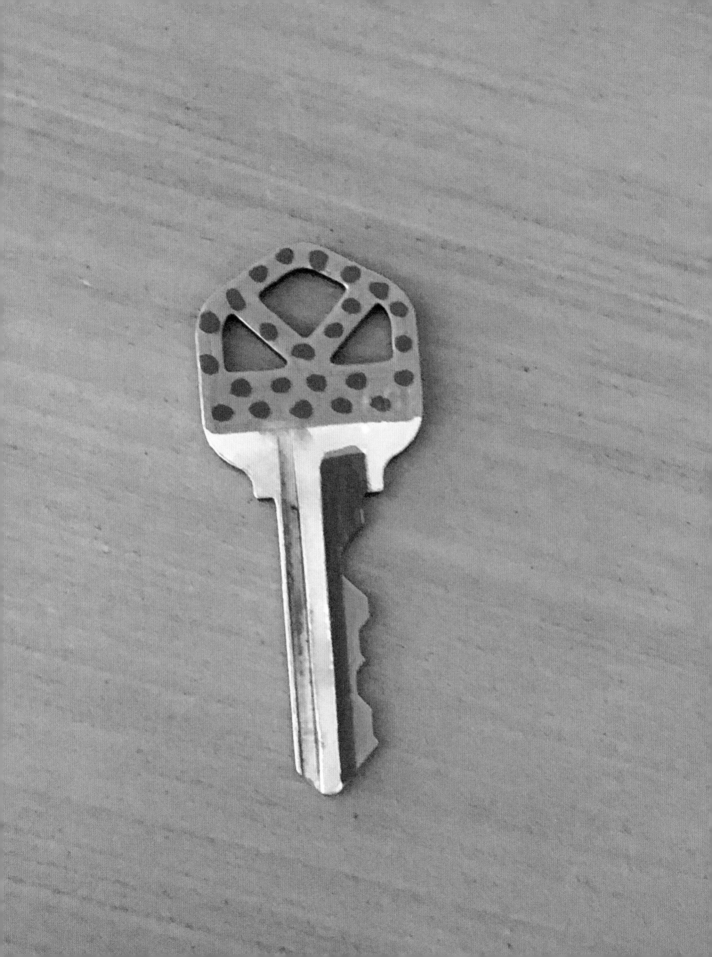

Step 1—Clean both sides of the key or keys that you will be decorating and allow them to dry completely.

Step 2—Use a pencil to trace the shape of the key onto paper and try out different designs. Practice making marks that will fit the surface of the key. It's a small area, but there are many ways that artwork could be applied. You use your keys every day so choose a design that you enjoy seeing. For instance, you can color just around the edges, around the top portion where it connects with the key ring, or all over with dots or stripes.

Step 3—Place the key on top of your cardboard-protected work surface and apply your design. Allow each side to dry thoroughly before flipping the key over.

Step 4—Time to enjoy the useful beauty of your creation. No more awkward fumbling between keys at the door now that each of your keys has its own distinct look!

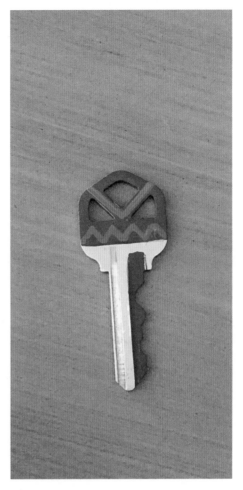

**Optional:** Keys see a lot of use and scraping. A clear coat will help to preserve your decorations. Allow your key to dry for several hours or, even better, let it set overnight before spraying it with a clear coat. Follow the instructions on the spray can closely. Make sure to spray paint in a well-ventilated area, preferably outside, and use cardboard beneath the key to contain it and keep the spray paint from getting on any unintended objects.

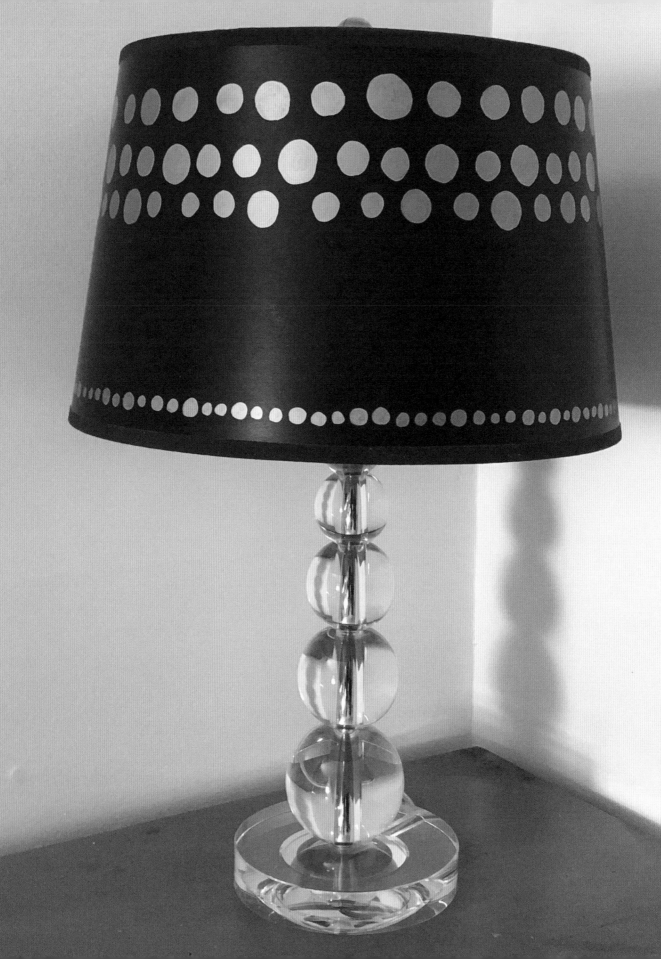

# LAMP SHADES—GORGEOUS GLOWING SHADES

*Brighten up your lamp by adding some decoration to a dull shade.*

## Supplies:

- Drum style lamp shade and a base to put it on
- Markers—Use stain markers if working on a fabric shade or oil-based markers if working on a cardboard shade
- Pencil and paper
- Cardboard

## Optional:

- Masking tape (**Note:** Not recommended if working with a paper shade as the masking tape can damage the surface.)
- Stencils

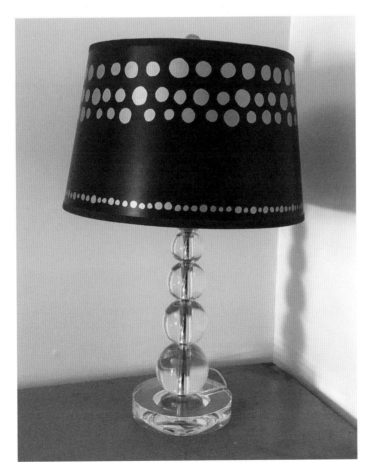

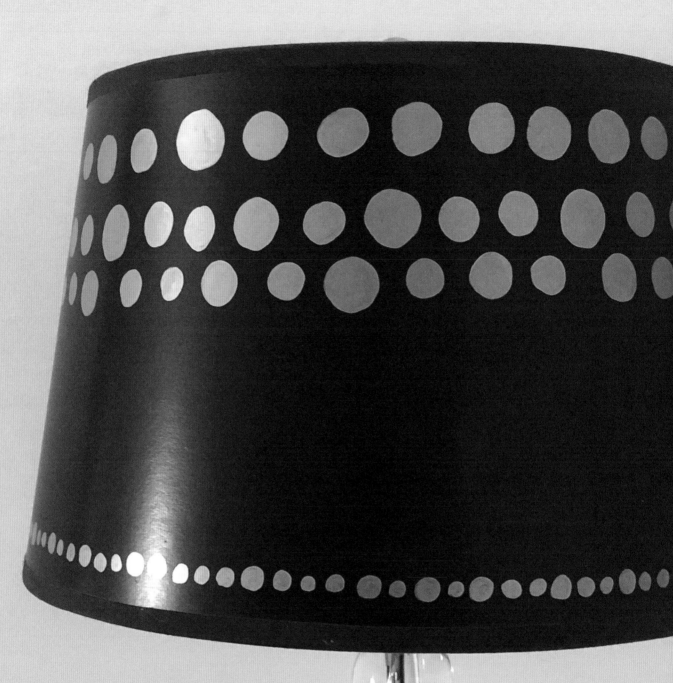

Step 1—Sketch some designs to apply to your shade. If working with a cardboard drum, lightly sketch your design on its surface. If working with a fabric shade, sketch out your design using a pencil and paper. Consider the lamp base and the décor of the room it will be used in. If there are any flaws in the shade, think of a design element to cover them up.

Step 2—Make sure that your shade is clean and free of dust before placing it on top of your cardboard-covered work surface. If working with stencils or using tape to create a template, apply them before you begin drawing the decoration. Work from top to bottom and rotate the shade as you decorate it. You may need to pause occasionally to allow areas to dry before proceeding.

Step 3—Wait for the shade to dry thoroughly before setting it atop a base and inserting a light bulb. The heat of the bulb will help to heat set the artwork over time. Enjoy the soft glow cast from your stylish new shade.

**Care Instructions:** Gently remove dust with a lint roller from fabric shades. Feather dusting works well on both cardboard and fabric shades.

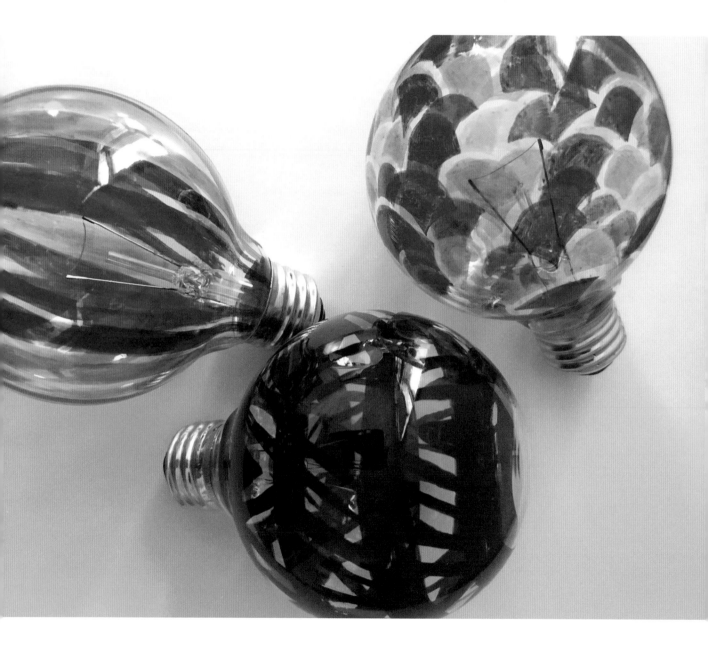

# LIGHT BULBS—LET THERE BE LIGHT (AND AMAZING SHADOWS!)

*Drawing on a light bulb adds interest to a light fixture with an exposed bulb and, when lit, will illuminate your room with lovely shapes, shadows, and hues cast by your artwork.*

**Supplies:**

- Clear light bulb—25- or 40-watt work particularly well
- Support object to help balance the round shape of the bulb as you decorate
- Permanent markers in a variety of sizes and colors
- Cardboard
- Pencil and white paper

**Optional:**

- Rubbing alcohol

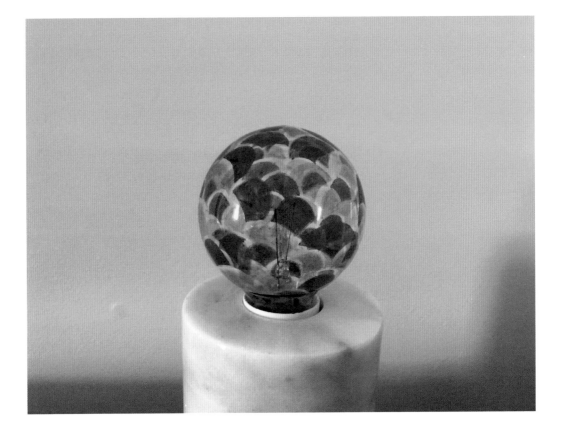

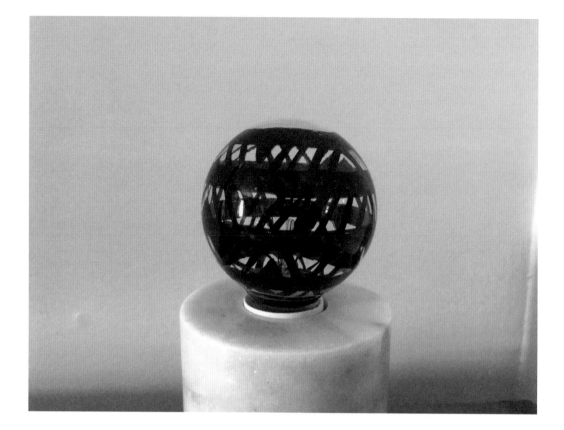

> **TIP:** Many of the individually sold bulb boxes create a great support when cut in half horizontally. If the bulb sleeve is not available, most any small, round-mouthed object, such as a jar or bowl, will work well. Alternatively, you can screw the bulb into the base that it will be used in; however, make sure the base is unplugged while you are working on your artwork.

**Step 1**—Gently clean the glass portion of the bulb and allow the bulb to dry completely.

**Step 2**—Sketch out some sketches for your bulb using a pencil and paper. When creating your design, keep in mind that you will be applying your decoration to a round shape. Thick, blocky shapes and patterns will cast clearer shadows against your walls,

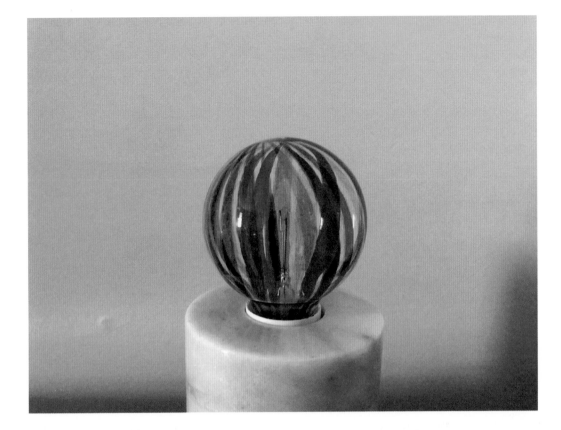

and any words will need to be reversed in order for the cast shadow to read clearly. Also, consider leaving some undecorated areas in your design so that you have somewhere that you can handle the bulb while decorating it. The metal tip can also work well as a handle. (**Note:** If you want to test this treatment out before applying your entire design, draw some sample shapes on your bulb, and light it near a wall to see what kinds of shadows are cast. Then remove the test drawings with rubbing alcohol.)

Step 3—Cover your work space with a piece of cardboard to protect it and set your light bulb upon it in your chosen support base. Handle the bulb delicately as you draw on it and take care to allow areas to dry before touching that portion of the bulb. As you draw, take the time to layer multiple strokes to achieve a rich color effect and maximize the results of your light and shadow display. Light colors will show up when the bulb is turned on but may be difficult to see when applying the art. If you're having trouble viewing the artwork, try placing a piece of white paper beneath the bulb to get a clearer view. (**Note:** If you get to a point where you are not yet finished but it has become difficult to manipulate the bulb without smearing the artwork, place the bulb in a base and turn it on to heat set the decoration for 10 to 20 minutes, then turn it off and allow the bulb to cool before resuming your drawing.)

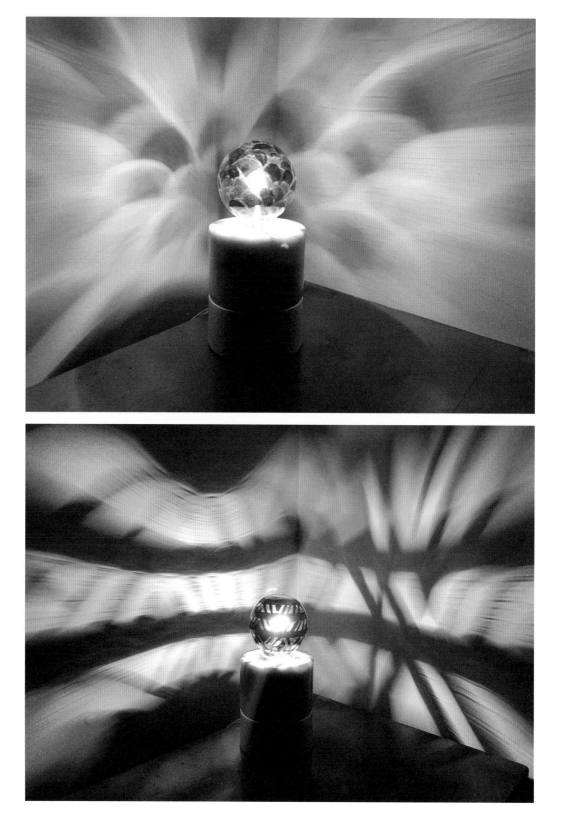

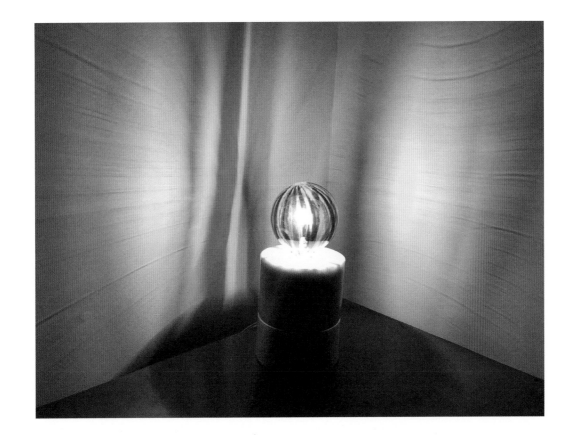

**Step 4**—When the artwork is complete, gently screw the light bulb into the base and turn it on. Experiment with the placement of your light. The shadows and shapes cast by your bulb will be more exaggerated the closer the light is to the wall or, even better, if placed in a corner for a dramatic look.

**Step 5**—The heat of the lit bulb will help to set the artwork after some use, but it will not be adhered to the bulb as thoroughly as an item that has been in the oven.

**Care instructions:** Avoid using any kind of chemical cleansers as this may damage or remove the art. Instead gently clean using a feather duster.

> **TIP:** Loving this effect? Try it out on a night light for a mini version! It also works great for festive mood lighting. Think spiders and cobwebs for Halloween or tree shapes at Christmas time or bright flowers for a Luau.

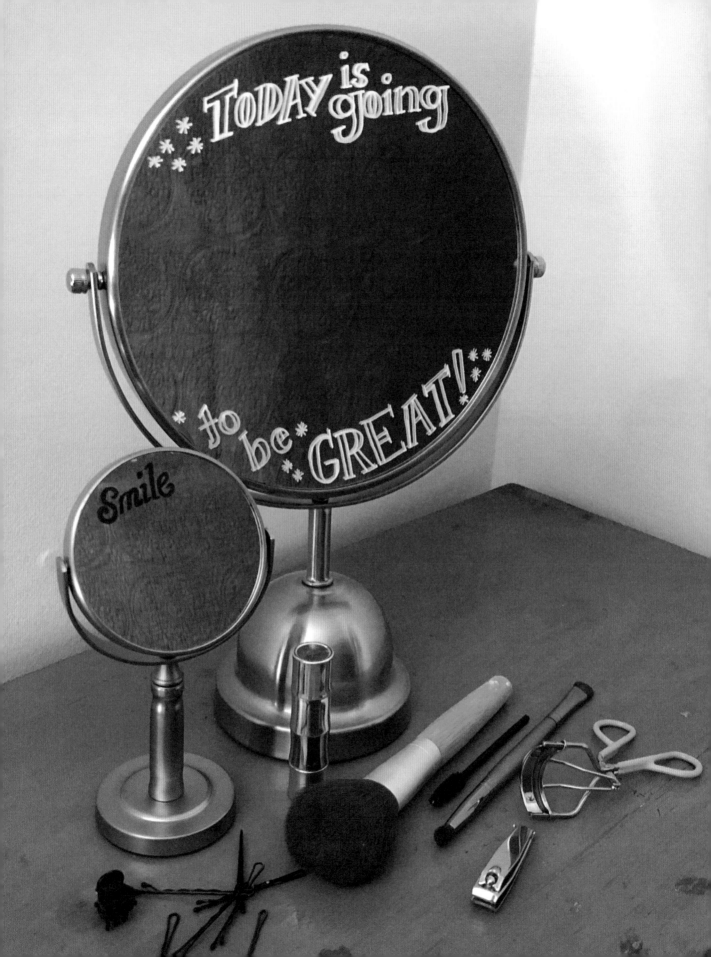

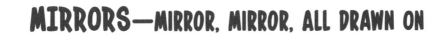

# MIRRORS—MIRROR, MIRROR, ALL DRAWN ON

*A mirror is a great opportunity to start your day off with a motivational message or a cheerful drawing.*

**Supplies:**

- Mirror—Any style will do
- Permanent Sharpie markers in a variety of shapes and colors—Use water-based paint pens for a more opaque look
- Cardboard
- Pencil and paper

**Optional:**
- Rubbing alcohol and cotton swabs

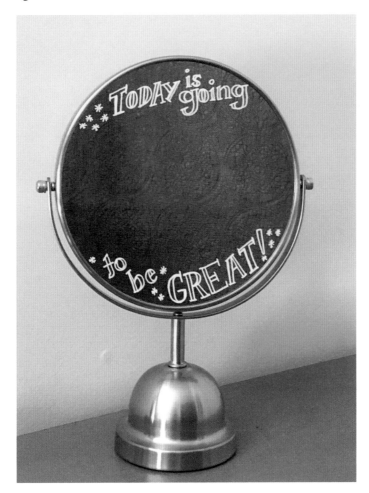

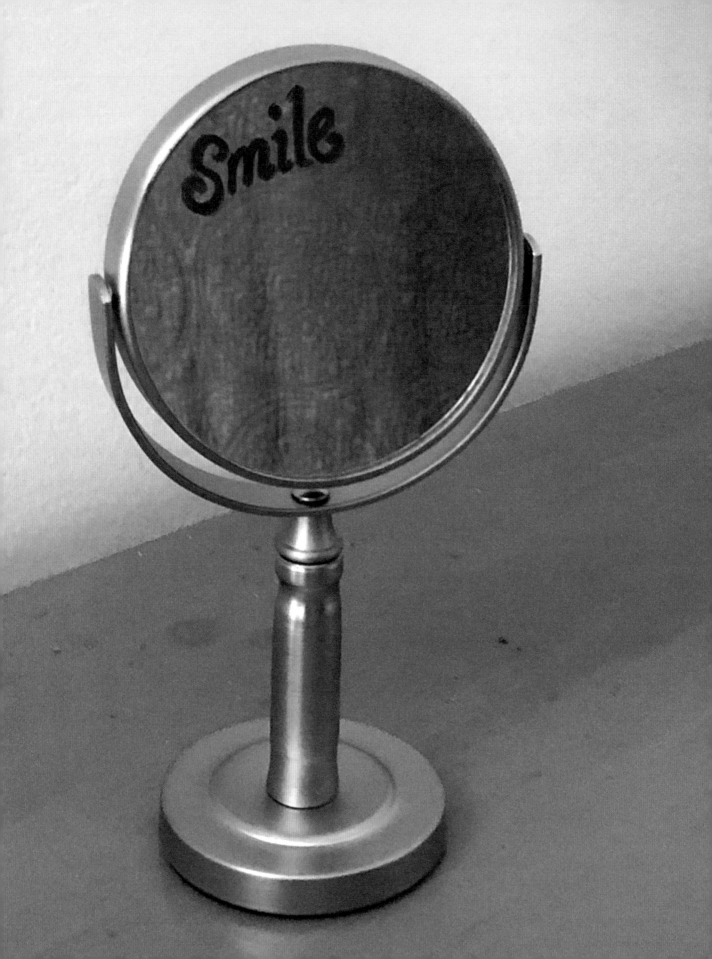

Step 1—Clean your mirror and allow it to dry thoroughly.

Step 2—Sketch out your design using paper and a pencil. Trace the shape of the mirror, if possible, to work on your sketch in the same size as the mirror.

Step 3—Apply your design to the mirror. You may want a small piece of paper to cover the areas of the mirror that you want to keep clear so that you have somewhere to rest your hand while drawing. If you're having trouble seeing the artwork as you apply it because of the reflection, experiment with different angles. You may need to adjust several times while decorating the mirror. (**Note:** Gently dab at any unwanted lines with a cotton swab dipped in rubbing alcohol to remove them. Use the rubbing alcohol sparingly to prevent drips.)

Step 4—Enjoy being greeted each morning by the message that you designed for yourself. (**Note**: Don't limit to yourself to just one mirror. If you have a mirror by the front door it's the perfect place to put up reminders for yourself in a fun way or greet guests at a party.)

**Care Instructions:** Gently clean your mirror with a feather duster. When you're ready for a new look, use rubbing alcohol or glass cleaner to remove your art and give yourself a fresh surface.

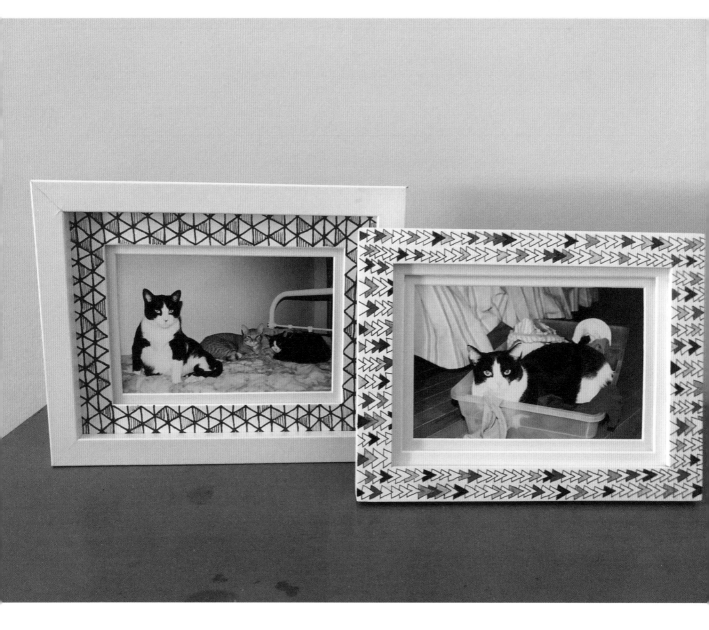

# PICTURE FRAMES—PICTURE PERFECT

*Add extra personalization to precious moments and photos by decorating the frames to coordinate.*

**Supplies:**

- Picture frames
- Markers—Use permanent markers in a variety of sizes and colors, if working with a light-colored frame with a matte finish, or oil-based markers in a variety of sizes and colors, if working on a dark-colored or glossy frame
- Cardboard
- Pencil and paper

**Optional:**

- Spray clear coat

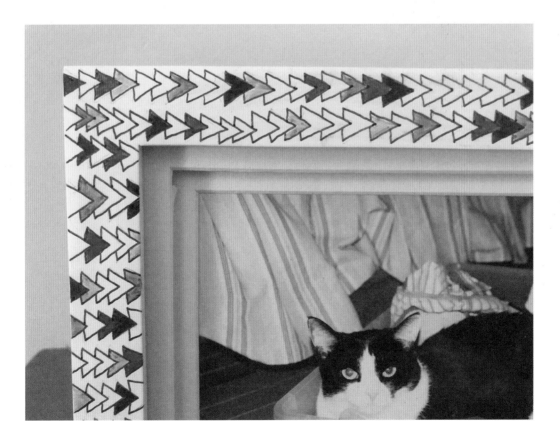

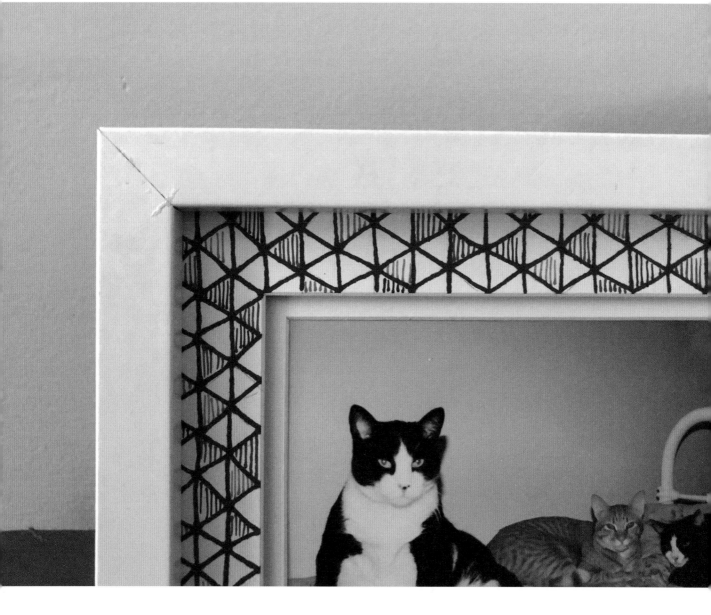

**Step 1**—Remove the glass and backing from the frame, and thoroughly clean and dry the individual components.

**Step 2**—Sketch out your design on the frame in pencil. If working on a frame with a glossy finish, you will not be able to apply pencil markings, so sketch your design on paper instead. Take inspiration from the photo that you intend to insert into the completed frame and consider something to complement it and your room décor.

**Step 3**—Place the frame on top of your cardboard-protected work surface and apply your design to the frame. You may also want to apply a pop color to the inner or outer edge and decorate the pre-cut mat if the frame came with one. (**Note:** If your design calls for decoration to be applied to the glass as well, wait until the frame is put back together and the photo is placed in it to ensure it lines up as planned.)

**Step 4**—Wait for your artwork to dry thoroughly before reassembling the frame and placing it on your wall or shelf to enjoy.

**Optional:** A clear coat is recommended if a more durable finish is desired to preserve the decoration. Allow the artwork on the frame to dry for several hours or, even better, let it set overnight before spraying it with a clear coat. Follow the instructions on the spray can closely. Make sure to spray paint in a well-ventilated area, preferably outside, and use cardboard beneath.

**Care Instructions:** Clean your frame by gently wiping it down and dusting as needed.

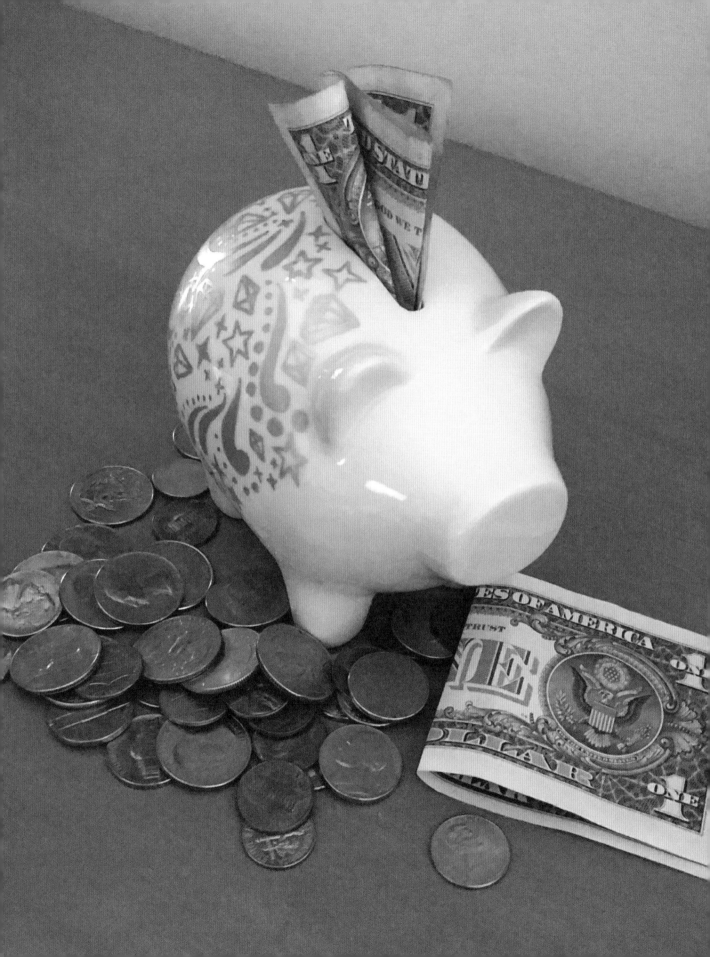

# PIGGY BANKS—LOVELY LITTLE PIG

*Make saving for rainy day fun by applying some decorations to your bank.*

**Supplies:**

- Ceramic bank—A matte finish works best
- Oil-based markers in a variety of sizes and colors
- Cardboard
- Pencil and paper
- Oven and baking sheet

**Optional:**
- Paint/varnish remover and cotton swabs

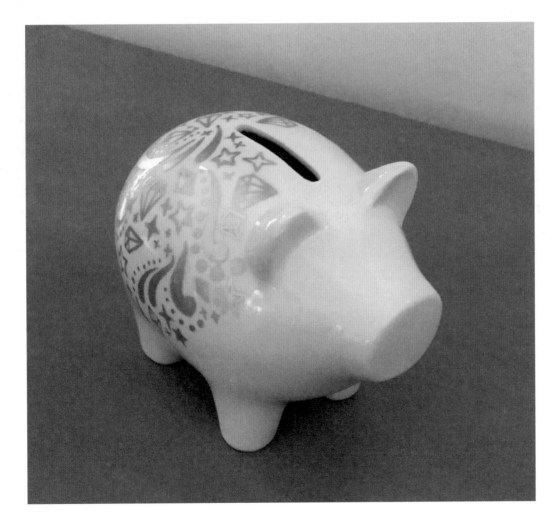

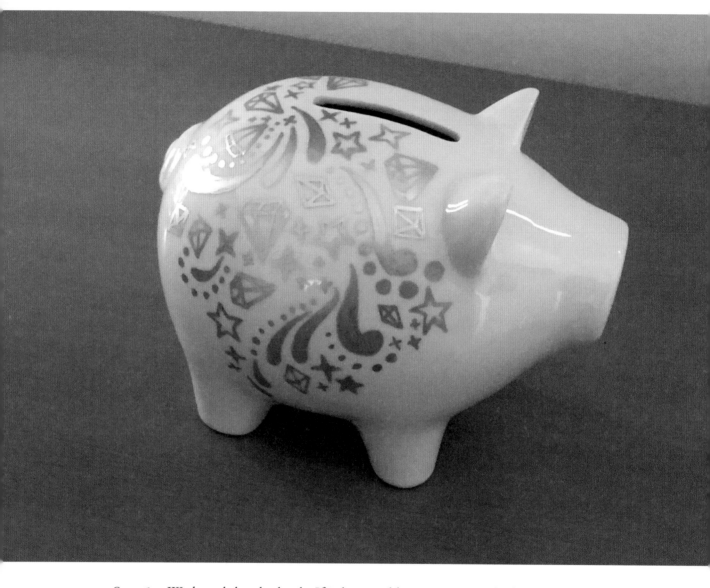

**Step 1**—Wash and dry the bank. If it has a rubber stopper on the bottom, remove it and set it aside for later.

**Step 2**—Sketch out ideas for the decoration that will pair well with the shape of the bank. If the money set aside in it is being saved for a particular purpose or event, including elements of that into your design will inspire you every time you contribute to your fund.

**Step 3**—Place your bank on top of a cardboard-protected work surface and apply the decoration. Take care to rotate as you go and allow areas to dry to prevent smudging.

(**Note:** If needed, use a small amount of paint/varnish remover on a cotton swab to gently dab away any unwanted lines or smudges.)

Step 4—Let your bank dry for several hours or, even better, overnight before placing it in the oven.

Step 5—Set your bank on a cookie sheet and place it in the oven before turning it on.

Step 6—Heat the oven to 350 degrees and set a timer for 30 minutes. When the 30 minutes are up, turn off the oven but do not remove the object. Leave it in the oven until the oven cools completely.

**Care Instructions:** Clean your bank by gently hand washing and drying it.

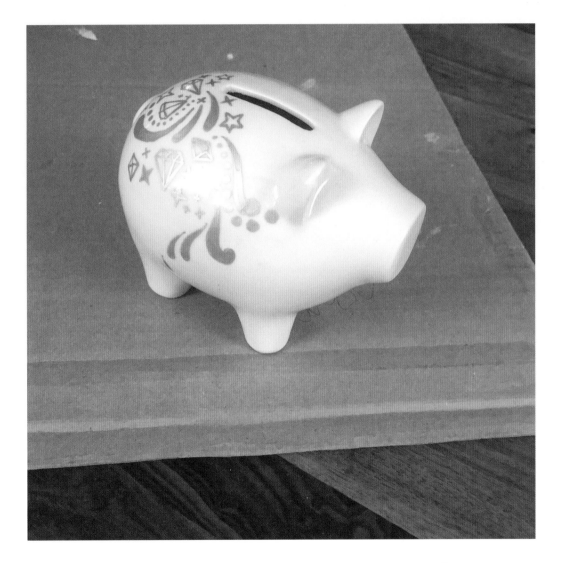

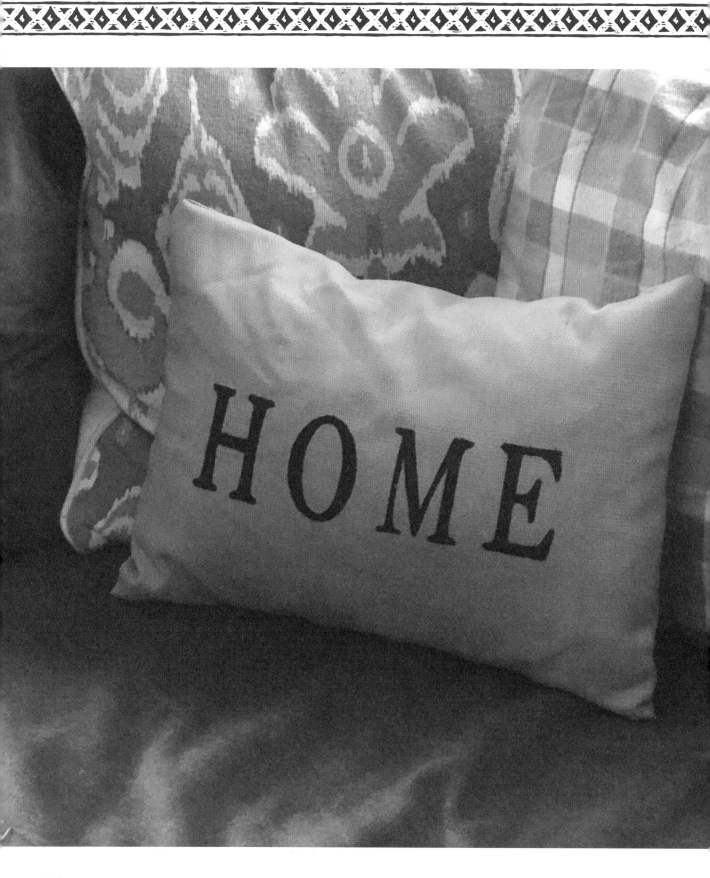

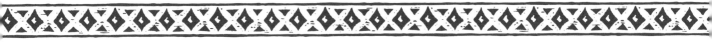

# PILLOWS—MESSAGE ON A PILLOW

*Let your pillow speak for you by applying a word or quote.*

**Supplies:**

- Pillowcase, preferably cotton
- Pillow filler
- Markers—Permanent markers and stain markers work best on a white or light-colored pillowcase. If you are drawing on a dark-colored pillowcase, oil-based markers will work best
- Individual letter stencils—You can make these yourself or purchase them in a craft store
- Masking tape
- Pencil and paper
- Hot iron or dryer
- Ruler

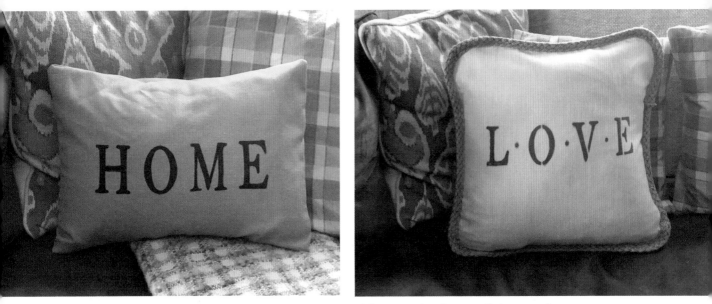

Ultra fine permanent markers are recommended for crisp borders outlining your letters. You can see the difference in the photos. The artwork on the Home pillow was applied using a marker with an ultra fine tip, and the artwork on the Love pillow was drawn using a marker with a fine tip.

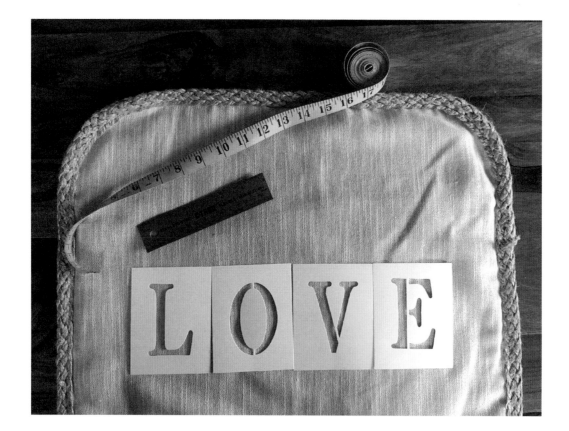

**Step 1**—Clean and dry the pillowcase according to the manufacturer care instructions before beginning.

**Step 2**—Cut a piece of cardboard to the size of the pillowcase and insert it into the case to keep the decoration from bleeding through to the reverse side as you draw.

**Step 3**—Think about the placement of the wording, it could be on the center of the pillow, across the top or bottom, or written on a diagonal. Take into consideration what room the pillow will be placed in. *Welcome* or *Family* would be a lovely choice near a front door, and words like *Dream On* or *Goodnight* would be terrific on a bed. Move your stencil around until you are satisfied, position the letters to form whatever wording you would like and secure them individually to the pillow with masking tape. (**Note:** Use your ruler if you want the word to be lined up straight and evenly positioned.)

**Step 4**—Use an ultra fine marker to lightly trace the outline of each letter onto the pillowcase. Press down on the stencil to hold it securely against the fabric as you trace the shape.

**Step 5**—Remove the stencils, clean up any untidy edges, and then fill in the outlines with marker.

**Step 6**—Allow the marker to thoroughly dry, then use a hot iron or warm dryer to heat set the art.

**Step 7**—Place your pillowcase on your pillow and snuggle up. (**Note:** If you have spare pillowcases this treatment is a wonderful way to add festive flair for holidays or special events.)

**Care Instructions:** Clean your pillowcase by hand washing and line drying it.

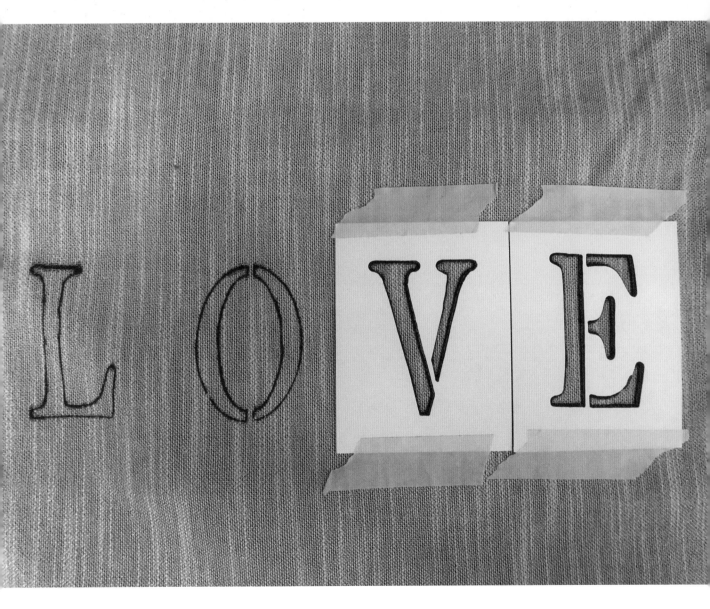

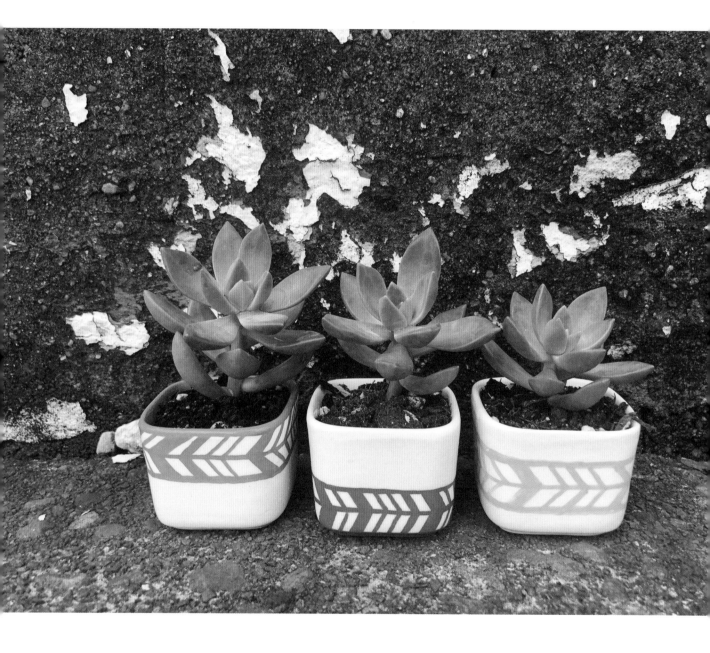

# PLANTERS—GROWN UP AND GREENED UP

*Spruce up your plants by decorating the pots. (The technique for this project will vary depending on if you are working with a terra-cotta pot or a glazed ceramic pot. Instructions for both are included.)*

## CLASSY CERAMIC CONTAINERS

Supplies:

- Ceramic pots—A matte finish works best
- Oil-based Sharpies in a variety of sizes and colors
- Cardboard
- Pencil and paper
- Oven and cookie sheet

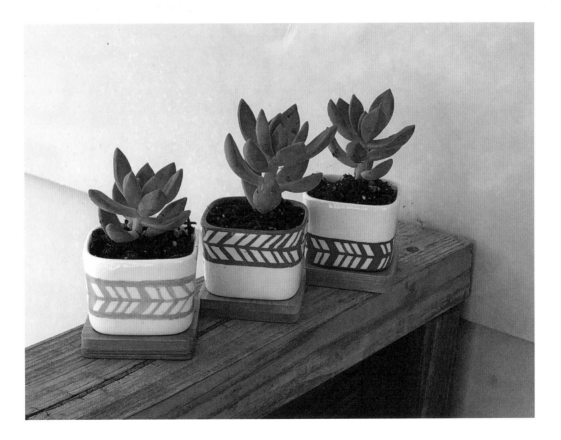

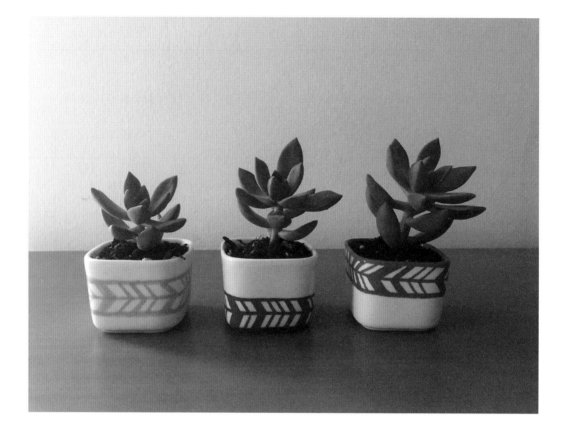

**Step 1**—Thoroughly clean and dry the pot you will be decorating.

**Step 2**—Sketch designs, considering the shape and scale of your pot. If you know what type of plant you will be placing in the pot, the color of the foliage and shape of the plant may also be taken into consideration when creating your design.

**Step 3**—Place your pot on top of a cardboard-covered workspace. Testing your artwork on the base of the pot first is recommended. Once the base is dry, flip it over onto the rim and rotate it as you draw your designs.

**Step 4**—Let your pot dry for several hours or, even better, overnight before placing it in the oven.

Step 5—Set your pot on a cookie sheet and place it in the oven before turning it on.

Step 6—Heat the oven to 350 degrees and set a timer for 30 minutes. When the 30 minutes are up, turn off the oven but do not remove the object. Leave it in the oven until the oven cools completely.

Step 7—Once the pot is thoroughly dry, fill it with a plant and enjoy.

**Care Instructions:** Clean your pot by gently hand washing and drying it.

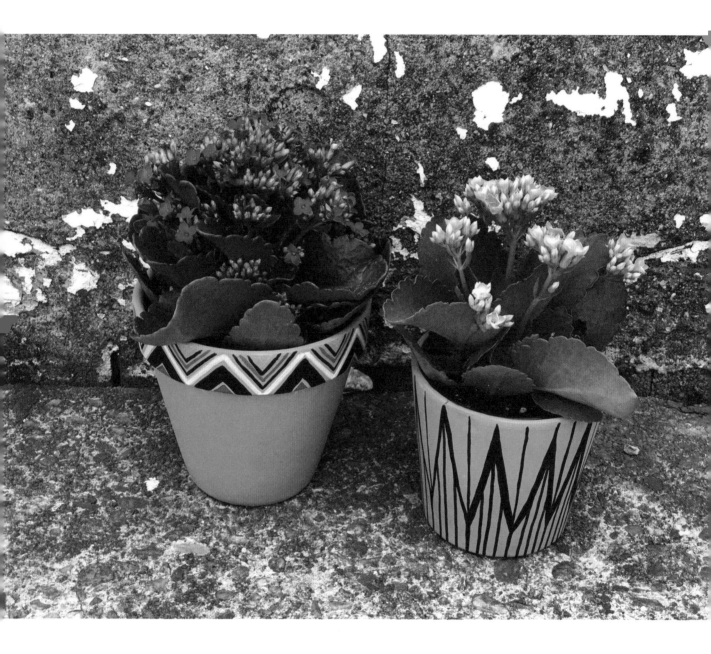

## TERRIFIC TERRA-COTTA POTS

**Supplies:**

- Terra-cotta pots
- Oil-based Sharpies in a variety of shapes and colors
- Pencil
- Cardboard

**TIP:** Paint/varnish remover does not work well to remove mistakes and smudges on terra-cotta surfaces as the porous nature of terra-cotta causes many colors to bleed and spread instead of being removed completely. As an alternative solution, incorporate any errors into your design by thickening lines, coloring in an area, or adding an additional detail. You can test this out on the bottom of the flower pot or saucer.

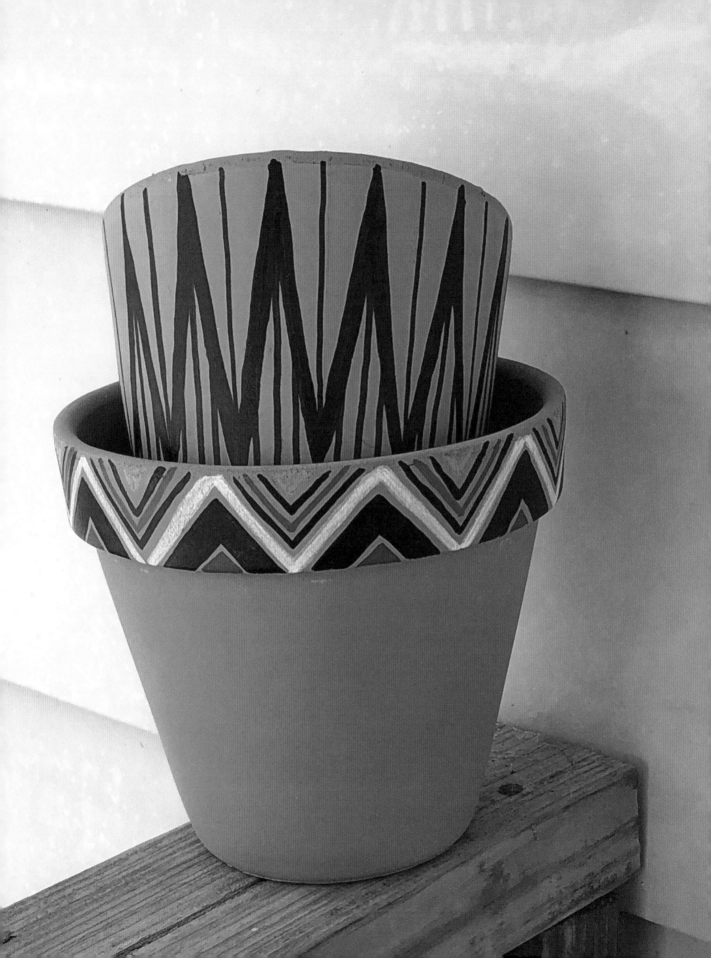

**Step 1**—Use a pencil to sketch out your design on the terra-cotta pot. Don't forget to add a detail to the bottom of the flower pot. This will give you an opportunity to get comfortable with applying ink to the terra-cotta surface before proceeding to the viewable areas of the flower pot. If your pot has a coordinating drainage dish or saucer, consider decorations for this portion as well.

**Step 2**—Place your terra-cotta pot face-down on a cardboard-protected work surface. Apply oil-based markers to the design on the bottom of your pot and allow it to dry thoroughly before flipping it over.

**Step 3**—Fill in your design on the outer surface of the flower pot. Allow paint to dry thoroughly before overlapping colors.

**Step 4**—Once the pot is thoroughly dry, fill it with a plant and enjoy.

**Care Instructions:** Clean your pot by gently hand washing and drying it.

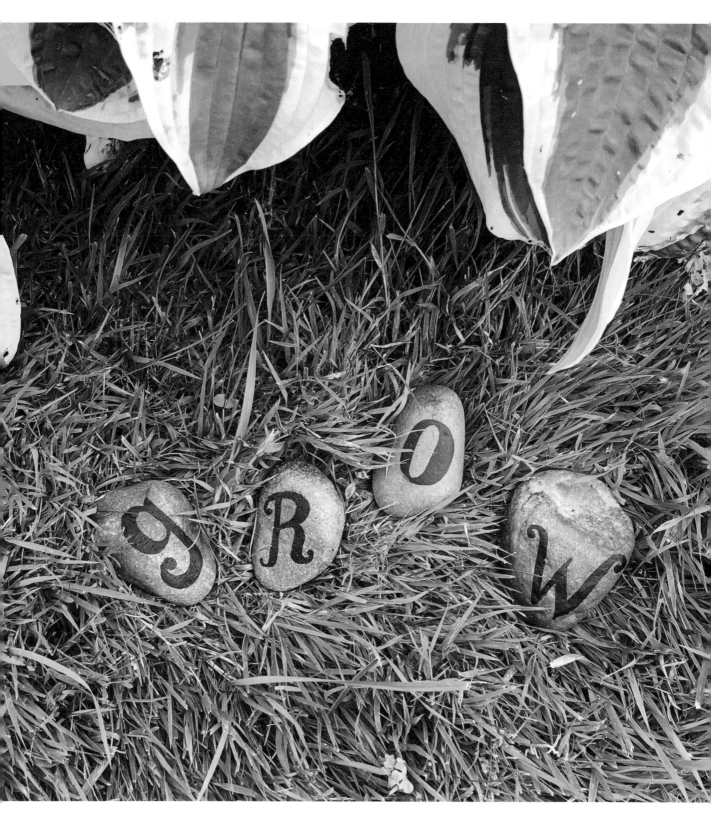

# RIVER ROCKS—ROCKS THAT ROCK

*A humble rock becomes a showpiece after receiving the Sharpie treatment.*

**Supplies:**

- Smooth river rocks—Any size will do. Keep in mind when selecting rocks far from home that you have to carry them back
- Oil-based Sharpies in a variety of sizes and colors
- Cardboard
- Pencil

**Optional:**

- Clear spray coat
- Paint/varnish remover and cotton swabs

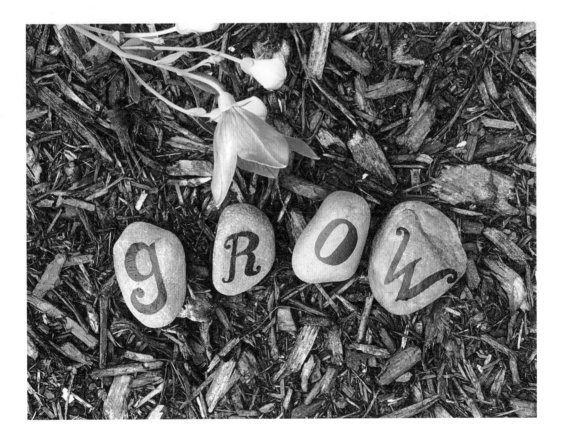

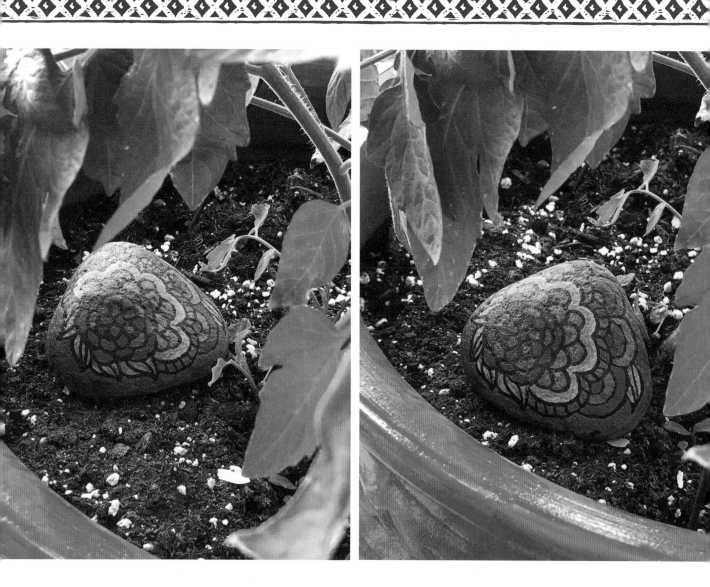

**Step 1**—Thoroughly clean your river rocks using soap, water, and a scrub brush or even an old toothbrush to remove grit and moss. Allow the rocks to thoroughly dry. Rocks are porous, so this can take a while. Putting them in a sunny spot will help speed the process along.

**Step 2**—Use pencil to sketch designs directly onto the river rock.

**Step 3**—Place your rock on a cardboard-protected work surface. Draw over the sketches with marker. If layering different colors, allow drying time between applications. (**Note:** Unwanted lines and smudges can be cleaned up with paint/varnish remover and a cotton swab. Use paint/varnish remover sparingly and test on the bottom beforehand as

each rock is different and some are more porous than others and will absorb the thinner and cause it to bleed instead of removing blemishes.)

Step 4—Place your rocks in the environment where you envisioned them. They work especially well in flower beds and planters but also add a touch of whimsy and delight to a desk, bathroom, or guest bedroom.

**Optional:** Rocks that are placed outside will receive a lot of abuse from the elements. A clear coat is recommended to preserve the decoration. Allow the paint on your rock to dry for several hours or, even better, let it set overnight before spraying it with a clear coat. Follow the instructions on the spray can closely. Make sure to spray paint in a well-ventilated area, preferably outside, and use cardboard beneath the rocks to contain them and keep the spray paint from getting on any unintended objects.

**TIP:** Decorating seashells is a lovely alternate take on this project.

# SWITCH PLATES—SWITCH PLATES WITH STYLE

*Switch out your simple switch plates and outlet covers for something more stylish.*

**Supplies:**

- Switch plates that fit the switch or outlet that you want to cover—Usually these are metal or plastic, and either style works well.
- Markers—Permanent markers in a variety of sizes and colors work well on a plastic switch plate. If working on a metal switch plate, use oil-based Sharpie paint pens instead
- Cardboard
- Paper and pencil

**Optional:**

- Spray paint clear coat

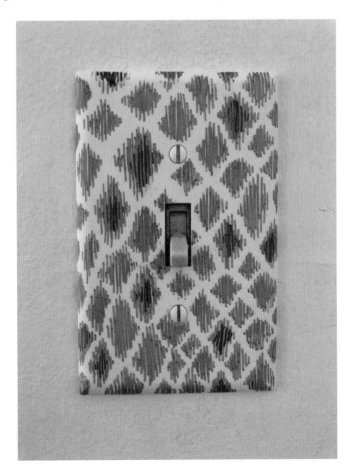

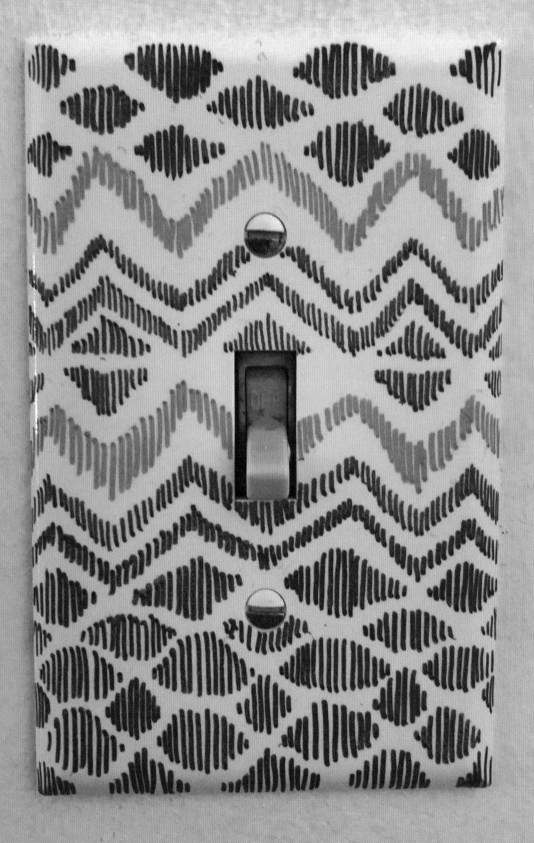

**Step 1**—Trace the shape of your switch plate onto some scratch paper and sketch out a design. Don't forget about the areas where the screws will go; the screws can be decorated as well if you desire. As this is for your home, drawing design and color inspiration from your surrounding décor is a wonderful idea. Decorating your switch plate can even help it blend into a collage wall if you have a grouping of art and photos near it.

**Step 2**—Clean and thoroughly dry the switch plate, setting the screws aside.

**Step 3**—Place the switch plate on top of your cardboard-protected work surface and decorate it with your unique design.

**Step 4**—Once your custom switch plate has completely dried, add it to the wall and enjoy!

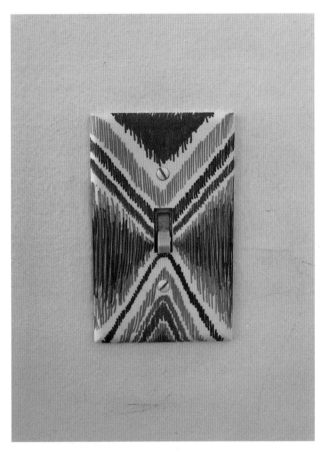

**Optional:** Switch plates are touched frequently, and the oils from hands can rub off the artwork over time. A clear coat is recommended to preserve the artwork on your custom switch plate. Allow your art to dry for several hours or, even better, let it set overnight before spraying it with a clear coat. Follow the instructions on the spray can closely. Make sure to spray paint in a well-ventilated area, preferably outside, and use cardboard beneath the switch plate to contain it and keep the spray paint from getting on any unintended objects.

**TIP:** If you choose to decorate the heads of the screws, pressing their tips into the cardboard is a great way to keep them from rotating while drawing on them.

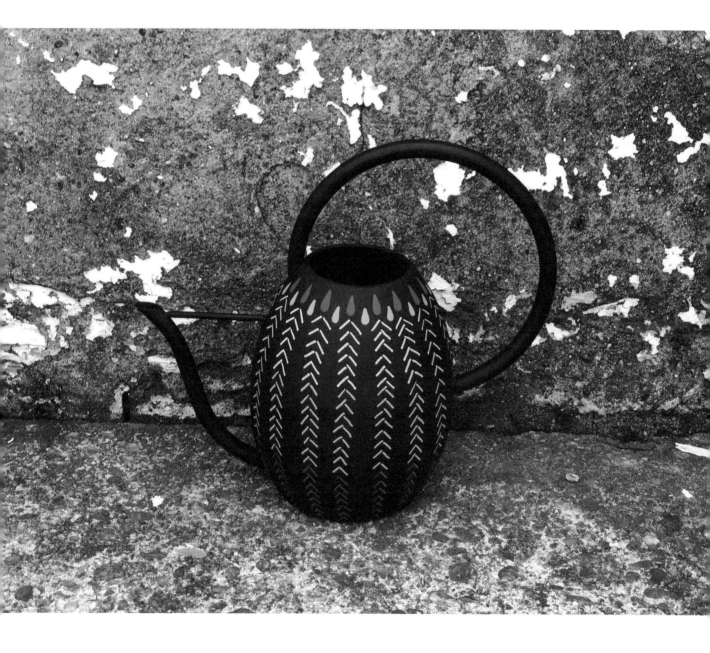

# WATERING CANS—WHIMSICAL WATERING CANS

*Has your watering can seen better days? Go green. Instead of replacing it, treat it to a fresh coat of paint and your beautiful decorations.*

**Supplies:**

- Metal watering can
- Oil-based Sharpies in a variety of sizes and colors
- Fine grit sandpaper
- Spray paint in the color of your choosing—A matte finish works best
- Cardboard
- Pencil

**Optional:**

- Clear spray coat
- Paint/varnish remover and cotton swabs

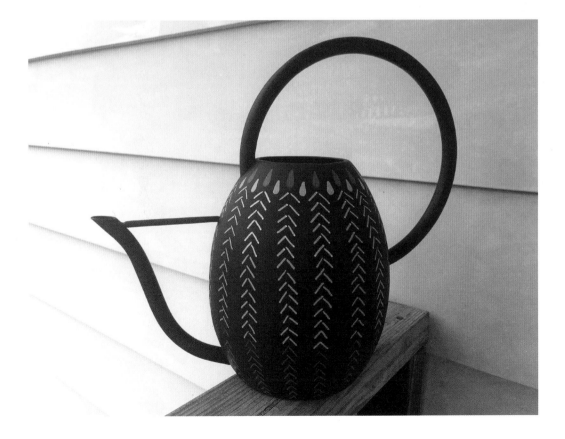

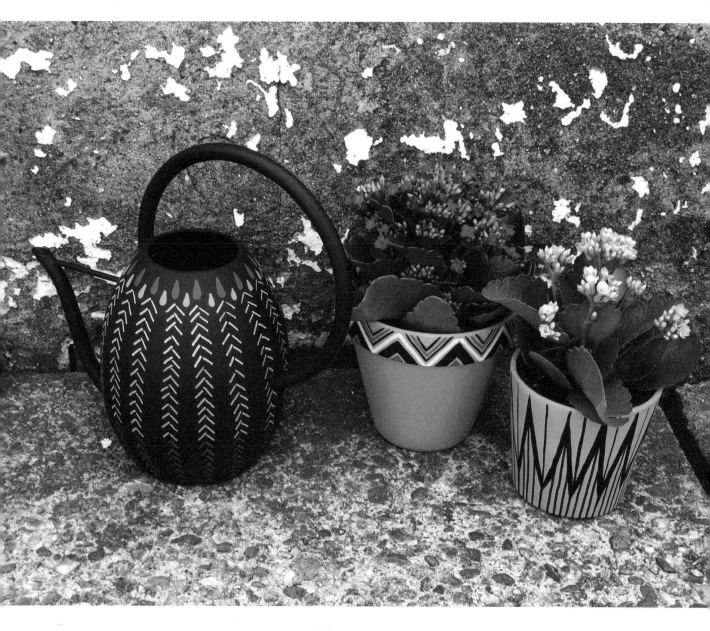

**Step 1**—Gently sand your watering can using the fine grit sandpaper, then clean and dry it thoroughly.

**Step 2**—Spray your dry watering can with the spray paint that you have selected. Follow the instructions on the spray can closely. Make sure to spray paint in a well-ventilated area, preferably outside, and use a cardboard box or drop cloth to contain the can and keep the spray paint from getting on any unintended objects. (**Note:** If

you want the underside of the can to be painted as well, wait at least a day for the top to dry completely before flipping the can to coat the underside.)

**Step 3**—Once the spray paint is thoroughly dry, place your painted watering can on top of your cardboard-protected work surface and lightly sketch your design on it.

**Step 4**—Once your sketch is complete proceed with applying oil-based markers to your design. Take breaks to allow your drawing to dry as you rotate the can to decorate it. (**Note:** Use paint/varnish remover to clean up any smudges or unwanted lines, if desired.)

**Step 5**—Enjoy watering your plants with your wonderful new watering can.

**Optional:** A clear coat can help to preserve your artwork if your watering can will be exposed to the elements. The process is very similar to applying the spray paint. Give your completed drawing several hours to dry or, even better, let it set overnight before spraying it with a clear coat. Follow the instructions on the spray can closely. Make sure to spray paint in a well-ventilated area, preferably outside, and use a cardboard box or drop cloth to contain the can and keep the spray paint from getting on any unintended objects.

**Care Instructions:** Care for your watering can by hand washing and drying it gently.

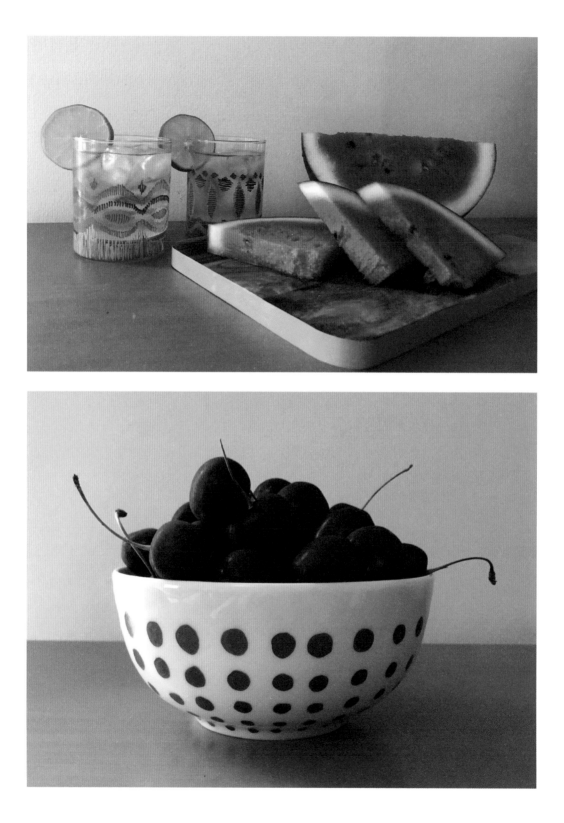

# CHAPTER 5

# KITCHEN AND DINING

Serve up your meals in style by using custom decorated
dinnerware and kitchen textiles.

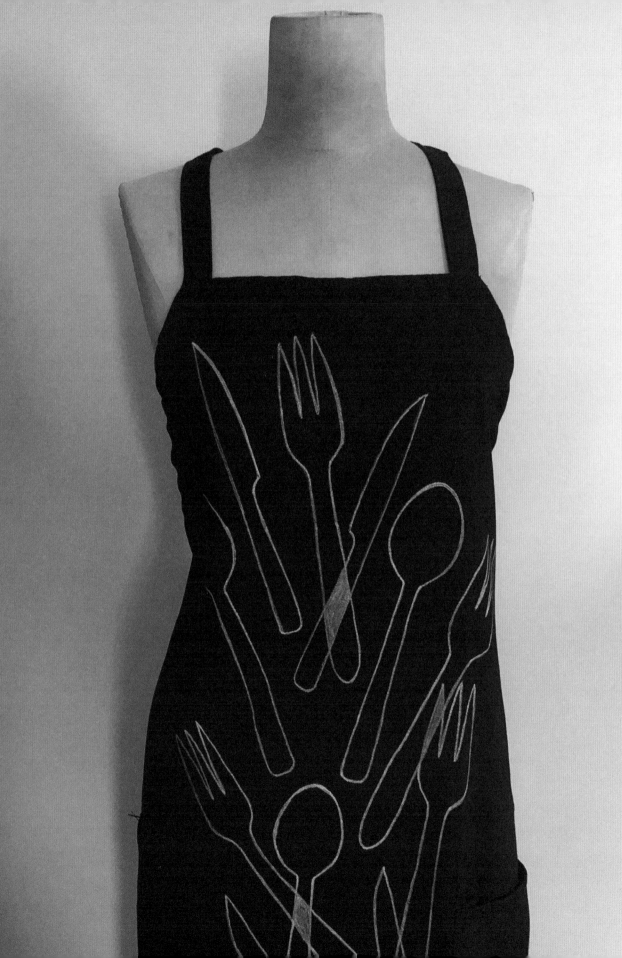

# APRONS—OUT-OF-THIS-WORLD OUTLINE APRON

*Who says food splatters are the only decoration that can be on an apron? Give your apron a fresh look by applying some adorable designs based on objects in your kitchen.*

**Supplies:**

- Apron, pre-cleaned and ironed
- Markers—Use stain markers and/or permanent markers in a variety of shapes and colors if working with a light-colored apron. Oil-based markers work best if working with a dark-colored apron
- Objects for tracing
- Pencil and paper, preferably a heavy weight paper or card stock
- Scissors
- Cardboard
- Hot iron or clothes dryer

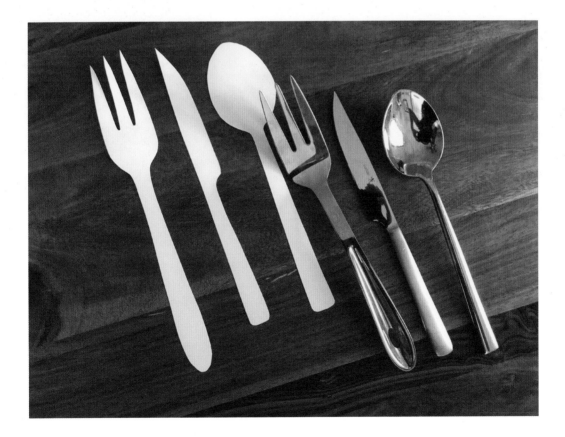

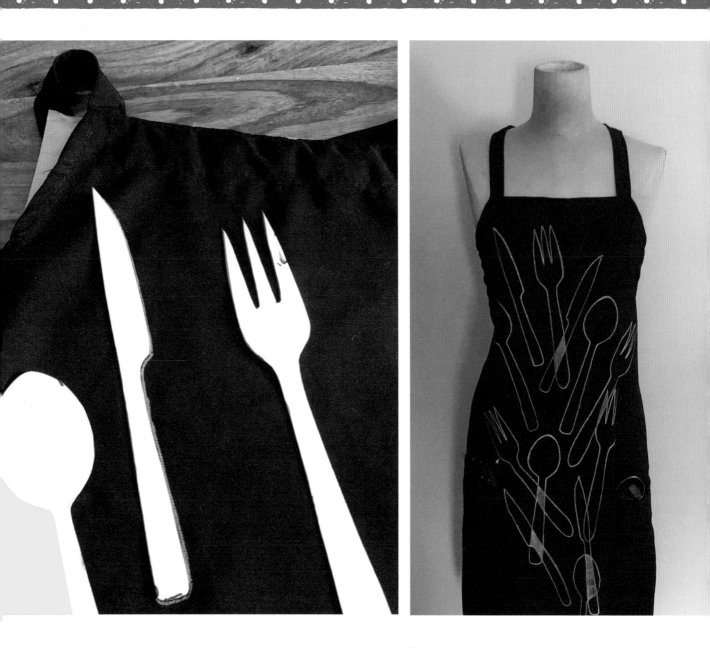

**TIP:** An apron is a large surface, you can certainly decorate the entire apron but don't feel pressured to do so. Designs applied just across the bib area, hem, or even just the pockets can be striking as well.

Step 1—Create your stencils by laying the objects that you have selected on your card stock and tracing them with pencil.

Step 2—Carefully cut out your shapes, taking extra care in areas with a lot of detail.

Step 3—In some cases you will be able to use your pencil to sketch directly onto the apron. Otherwise use your pencil and paper to sketch out the placement for where to apply the stencils.

Step 4—Place the apron on top of your cardboard-covered work surface and carefully position your stencils in the area that you wish to apply them. Hold your stencil firmly in place as you trace around it. If creating overlapping shapes wait for each area to dry before drawing the overlapping portion. Pause occasionally to reposition the apron on the cardboard and allow the edges of each stencil to dry before applying them to other areas of the apron.

Step 5—Go over the outlines again to thicken or deepen the color or fill in shapes and apply additional hand drawn details if desired.

Step 6—Allow your artwork to dry thoroughly before heat setting. To heat seal the artwork, either use a warm iron or place the apron in a warm dryer for 10 to 20 minutes.

Step 7—Enjoy cooking while wearing your chic new accessory.

**Care Instructions:** Prolong the life of your artistic apron by washing it in cold water and line drying it.

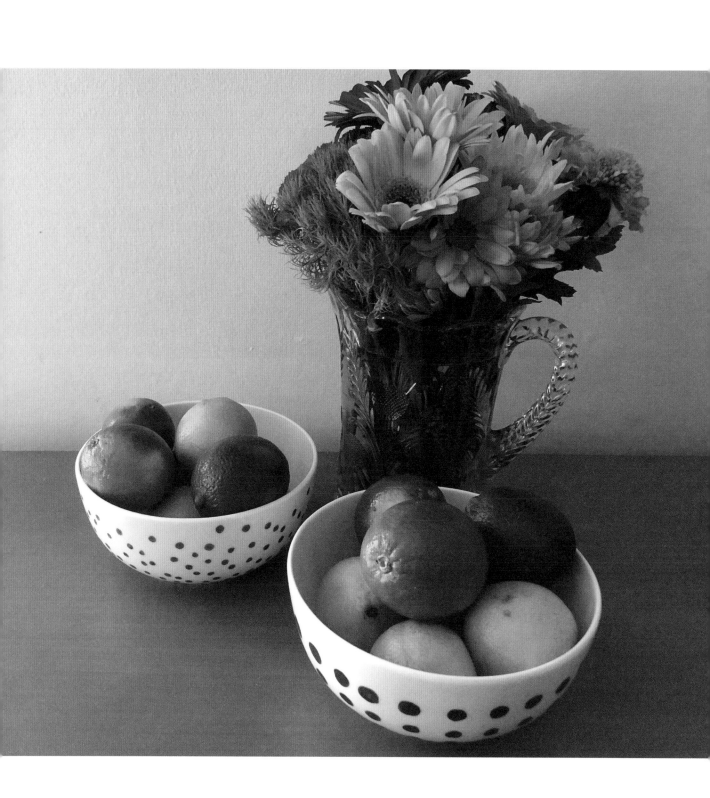

# BOWLS—BOWLED OVER BY BEAUTIFUL DISHES

*Add some whimsy to mealtime by adding adornments to your dinnerware.*

**Supplies:**

- Ceramic bowls in a color of your choosing—Your artwork will adhere best to ceramics with a matte or less glossy finish. This treatment can be used on coffee mugs and plates as well!
- Oil-based Sharpies in a variety of sizes and colors
- Cardboard
- Pencil and paper
- Baking sheet and oven

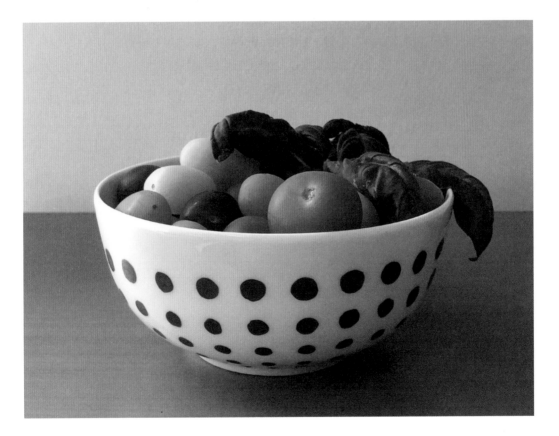

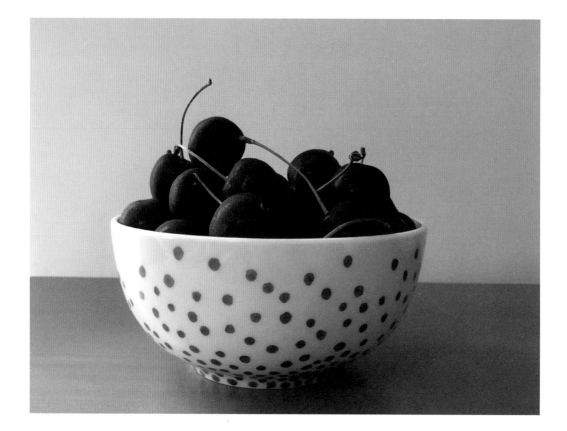

**Step 1**—Wash and thoroughly dry your bowl

**Step 2**—Sketch out your design, keeping the shape of the bowl in mind. (**Note:** Markers are not considered food-safe, so the artwork should not be applied to "active" eating areas where food will be placed.)

**Step 3**—Place your bowl on a cardboard-covered work surface and begin to apply your art. You may find it easier to place the bowl rim side down as the artwork should be concentrated toward the base of the bowl. Take your time applying art to the curved surface and rotate as you draw, avoiding touching any wet areas.

**Step 4**—Let your bowl dry for several hours or, even better, overnight before heat setting the artwork in the oven.

**Step 5**—Set your bowl on a cookie sheet and place it in the oven *before* turning it on.

**Step 6**—Heat the oven to 350 degrees and set a timer for 30 minutes. When the 30 minutes are up, turn off the oven but do not remove the object. Leave it in the oven until the oven cools completely.

**Step 7**—Bon appétit! Treat yourself to something tasty in your beautiful bowl.

**Care Instructions:** Gently hand wash and dry your bowl.

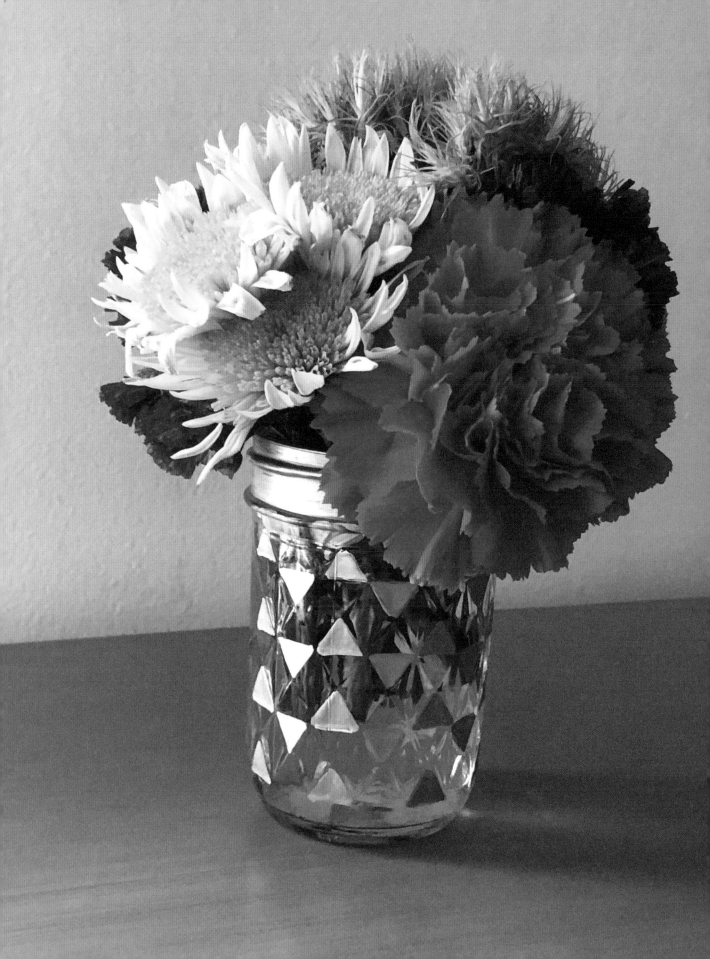

# GLASSES—GLASSWARE BUBBLING OVER WITH PERSONALITY

*Drawing on glassware is wonderful as a decoration and also very practical for being able to tell which glass belongs to each person at home, at the office, or at a party.*

**Supplies:**

- Glassware—Any type works well. Experiment with different shapes, from bud vases and juice glasses to wine glasses and decanters
- Oil-based markers in a variety of shapes and colors—Keep the size of the glass you are working on in mind when considering the various sizes of markers
- Cardboard
- Pencil and paper
- Oven and cookie sheet

**Optional:**

- Paint/varnish remover and cotton swabs

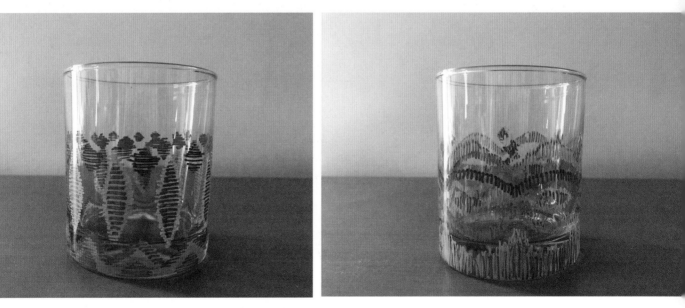

As demonstrated by these photos, the heat setting will have a huge impact on the durability of your art. Here are examples of glasses after being used and washed. The one on the [left] was heat set while the one on the [right] was not.

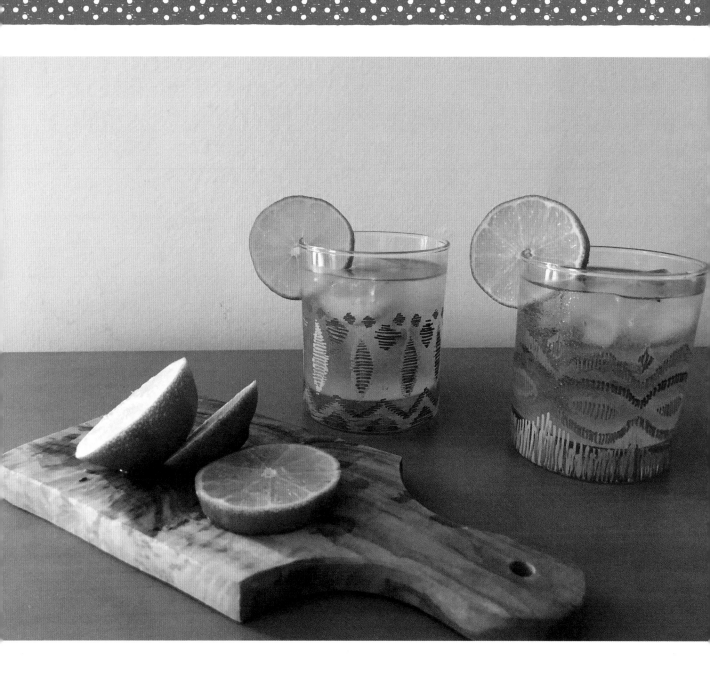

Step 1—Thoroughly wash and dry the glasses that you have selected.

Step 2—Sketch out your design ideas with pencil and paper. This can be a fun way to incorporate your favorite beverage, personalize the glasses, or coordinate them with your décor. Keep in mind that the markers are not food-safe, so the artwork should not be inside the glass or along the rim where someone will put their mouth.

**Step 3**—Place your glass upon your cardboard-protected work surface and apply your designs. (**Note:** If desired, paint/varnish remover can be used sparingly on a cotton swab to remove any flaws in the design.)

**Step 4**—Let your glass dry for several hours or, even better, overnight before placing it in the oven.

**Step 5**—Set your glass on a cookie sheet and place in the oven *before* turning it on.

**Step 6**—Heat the oven to 350 degrees and set a timer for 30 minutes. When the 30 minutes are up, turn off the oven but do not remove the object. Leave it in the oven until the oven cools completely.

**Step 7**—Bottoms up! Quench your thirst with a bubbly beverage.

**Care Instructions:** Gently hand wash and dry your new glassware.

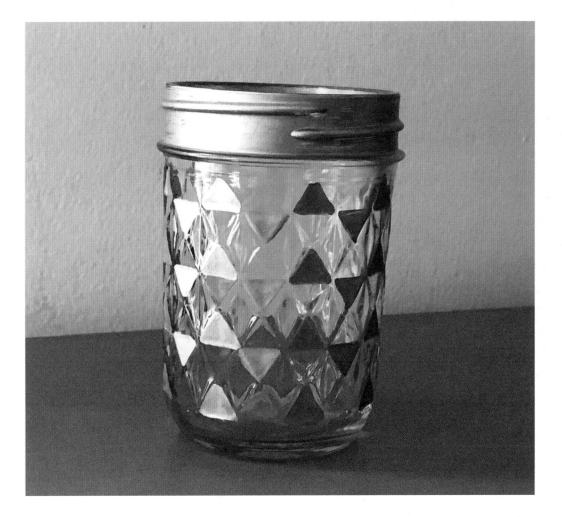

# NAPKINS—FABULOUS FABRIC NAPKINS

*Using fabric napkins instead of paper is eco-friendly and it also elevates your meal. Your hand drawn details will add additional intimacy and warmth to any occasion.*

**Supplies:**

- Pre-ironed napkins, preferably in a natural fabric like cotton
- Stain markers and/or permanent markers in a variety of sizes and color
- Cardboard
- Pencil and paper for sketching
- Hot iron or clothes dryer

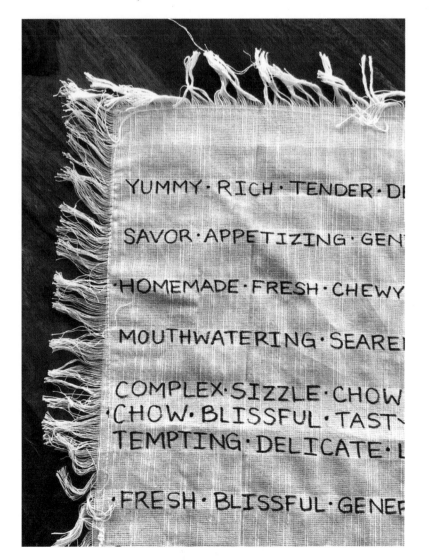

ICIOUS · CREAMY · COMFORT

ROUS · BUTTERY · BLISSFUL ·

CRUMPTIOUS · VELVETY

SIZZLE · SWEET · JUICY ·

ALTY · SWEET · SEARED ·

TENDER · CREAMY · CHEW

SH · TART · SUCCULENT ·

US · VELVETY · RICH · SAVOR

EMADE · SEARED · YUMMY ·

**Step 1**—Sketch out your idea, keeping your existing décor and tablescape in mind. (**Note:** If you want to try a similar look to the sampled design, create a list of words to be applied and try out different lettering styles. Applying this treatment to a striped napkin works beautifully as a guide for your lettering. If working on a non-striped napkin, a ruler or masking tape can be used as a guide for creating even lines to achieve the same effect.)

**Step 2**—Place your napkin on top of your cardboard-protected work surface. Do not fold it upon itself as the colors may bleed through to the other side as you start to draw. Make sure that the fabric of your napkin is facing upward as you apply your design. Use your thumb and forefinger to stretch each area taut as you decorate it to create clean crisp lines. Pause occasionally to reposition the napkin on the cardboard and allow the artwork to dry before moving on to other areas of the napkin.

**Step 3**—Allow your artwork to dry thoroughly before heat setting. To heat set the artwork, either use a warm iron or place the napkin in a warm dryer for 10 to 20 minutes.

**Step 4**—Enjoy your cheery, hand-crafted home good with meals and snacks.

**Care Instructions:** Wash in cold water and line dry for best results.

**TIP:** Hungry for more? This technique also works well on flour sacks and tea towels and can be used to create thoughtful custom gifts.

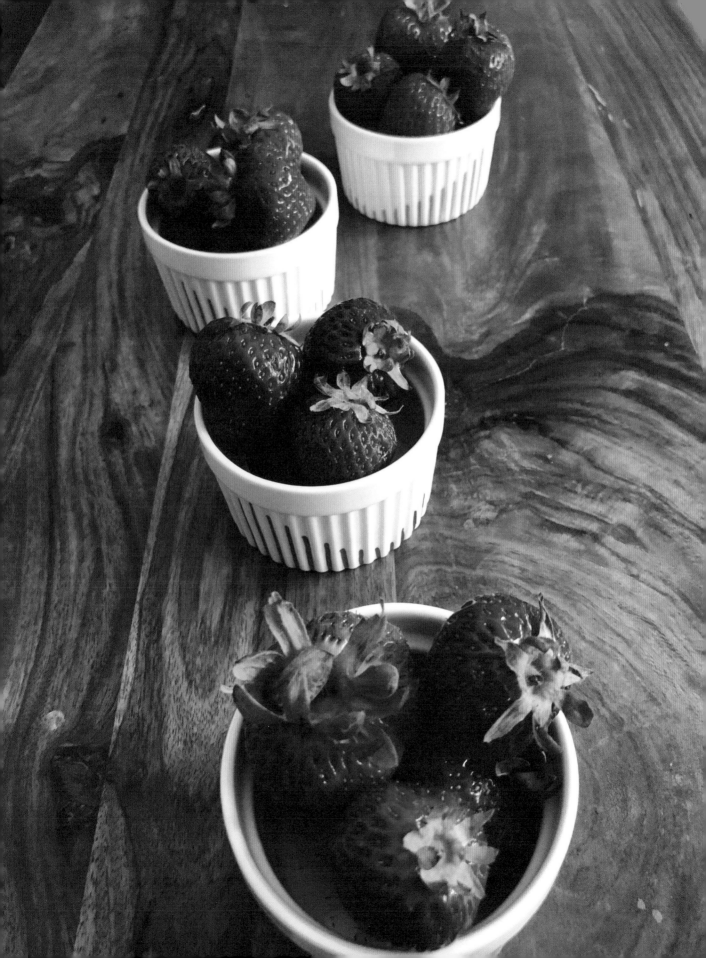

# RAMEKINS—RAINBOW RAMEKINS

*Ramekins are for so much more than just soufflés and crème brûlée. These cheery little guys are the perfect size for a midnight snack or one more scoop of ice cream.*

**Supplies:**

- Ceramic ramekins in a color of your choosing—Ones with a ridged texture are ideal for this project
- Oil-based markers in a variety of shapes and colors
- Cardboard
- Pencil and paper
- Oven and cookie sheet

**Optional:**
- Masking tape

**Step 1**—Thoroughly wash and dry your ramekin.

**Step 2**—Sketch out a design using your pencil and paper. Working with the ridges on the ramekin and using them as a guide is highly recommended. A number of looks can be achieved using this treatment. Consider drawing dashed or dotted line or use masking tape to create a pattern using lines of varying heights in diagonals across the surface. (**Note:** Keep in mind and that the markers are not considered food-safe so the artwork should not be applied to "active" eating areas, such as inside the dish.)

**Step 3**—Place your ramekin on a cardboard-protected work surface and carefully apply your artwork. (**Note:** If tape was applied, remove it and clean up any untidy edges.)

**Step 4**—Let the ramekin dry for several hours or, even better, overnight before placing it in the oven.

**Step 5**—Set your ramekin on a cookie sheet and place it in the oven *before* turning it on.

**Step 6**—Heat the oven to 350 degrees and set a timer for 30 minutes. When the 30 minutes are up, turn off the oven but do not remove the object. Leave it in the oven until the oven cools completely.

**Step 7**—Splurge on a sweet or salty snack.

**Care Instructions:** Gently hand wash and dry your ramekins.

# SERVING BOARDS—SERVING WITH STYLE

*Up your hors d'oeuvres presentation by adding an unexpected pop of color to a basic serving board.*

**Supplies:**

- Wooden board—Something without a glossy sealant will work best
- Oil-based markers in a variety of sizes and colors
- Cardboard
- Pencil and paper

**Optional:**
- Paint/varnish remover and cotton swabs

**Step 1**—Hand wash your board and allow it to thoroughly air dry.

**Step 2**—When planning your design for the board keep in mind that the markers are not food safe and should not be applied to any areas where food will be. If your board will be used for serving food the safest option is adding art along the border. It can be just a bright pop of color or a pattern sketched out all along the edge.

**Step 3**—Place the board on a cardboard-covered work surface and apply your design. It may take multiple coats to achieve a truly opaque look. (**Note:** Paint/varnish remover can be used sparingly to clean up any errors or smudges.)

**Step 4**—Enjoy serving snacks with style on your new board.

**Care Instructions:** Hand wash and dry your board for best results.

**TIP:** This treatment can also be applied to decorative planks with phrases such as "Home Sweet Home" or "Welcome." Another great alternate version is to use a plank as a guest book for a special event. A clear spray coat can be applied if the board will be used as a decoration rather than for serving food.

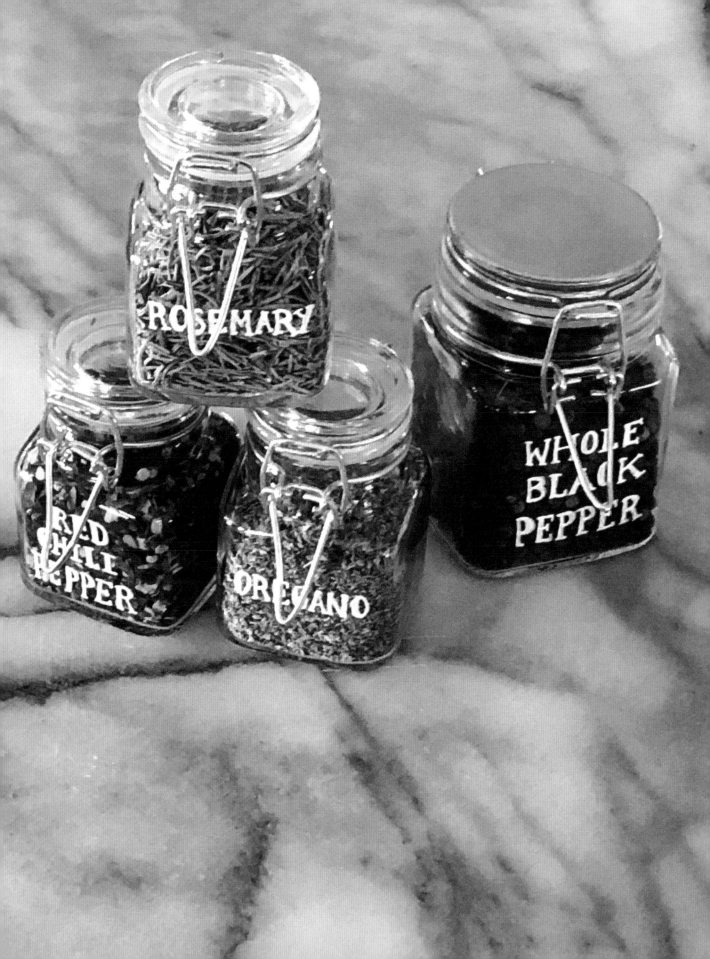

# SPICE JARS—THE SMART STORAGE SOLUTION

*Adding a handwritten label and/or decoration is a great way to bring some charm and uniform style to your jars.*

**Supplies:**

- Glass jars with a metal or glass lid that are appropriately sized for spices
- Oil-based Sharpies—Usually markers with an ultra fine tip work best, but a fine tip could work well on a larger spice jar
- Cardboard
- Pencil and paper
- Oven and cookie sheet

**Optional:**

- Labels for tracing

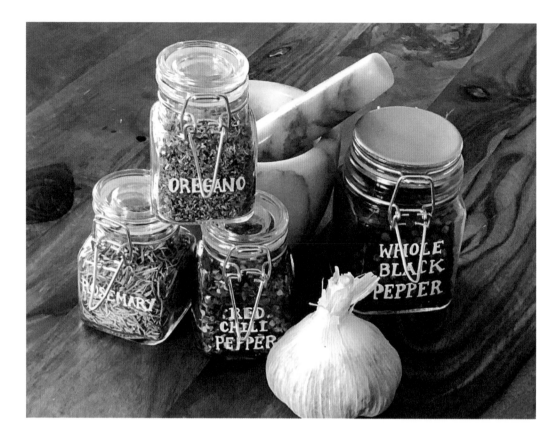

Step 1—Thoroughly clean and dry your jars. If they have a rubber stopper or seal around the mouth remove this element and set it aside for later.

Step 2—Trace the shape of your jar onto a piece of paper and try out several kinds of lettering to see what is most comfortable for you, what works best with the spices that you intend to fill the jars with, and how much space is available for decorating. Keep the color of the spice in mind when selecting which color marker you will use and select something that will contrast with the filling of the jar. If you keep your spices in a drawer consider decorating the lids as well. (**Note:** This project is a great opportunity to use labels as a stencil if you have them on hand. Just keep in mind, this will limit the lettering area and some spices have very long names.)

Step 3—Place your jars on top of your cardboard-protected work surface and apply your decorations. Remember that the markers are not food-safe so the decoration should be on the outside of the jar only.

Step 4—Let your jars dry for several hours or, even better, overnight before placing them in the oven.

**Step 5**—Set your jars on a cookie sheet and place them in the oven *before* turning it on.

**Step 6**—Heat the oven to 350 degrees and set a timer for 30 minutes. When the 30 minutes are up, turn off the oven but do not remove the object. Leave it in the oven until the oven cools completely.

**Step 7**—Replace the rubber seals before placing the corresponding spice in each jar.

**Care Instructions:** Gently hand wash and dry your jars.

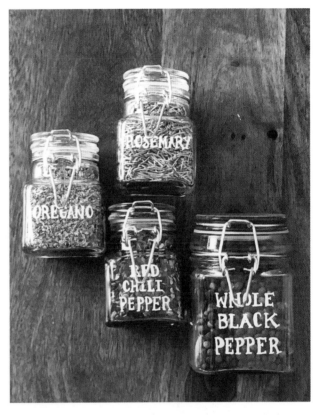

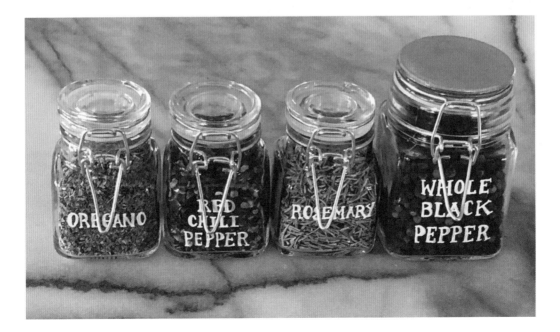

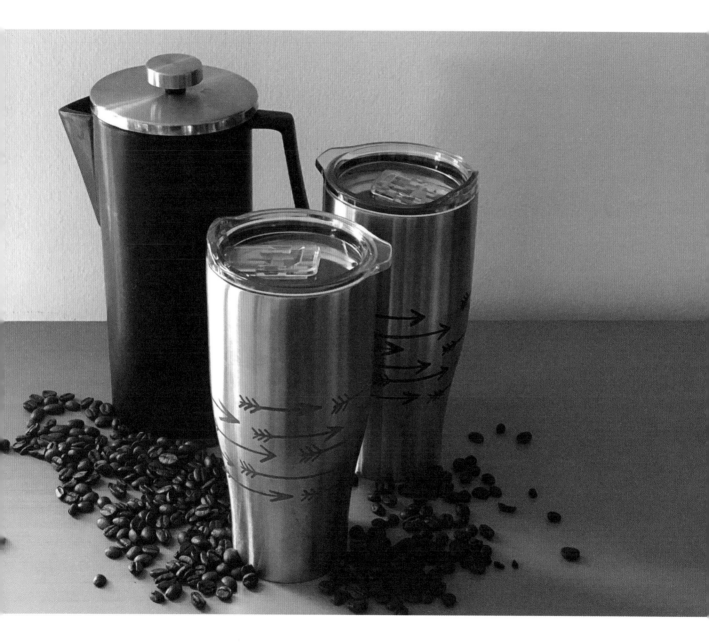

# STAINLESS STEEL MUGS—STAINLESS STYLE ON THE GO

*Drinking from the wrong cup of coffee is a drag. Make your cup stand out by customizing it!*

Supplies:

- Stainless steel travel mugs—Those without a glossy top coat work best
- Oil-based Sharpies in a variety of shapes and colors
- Pencil and paper
- Cardboard
- Oven and cookie sheet

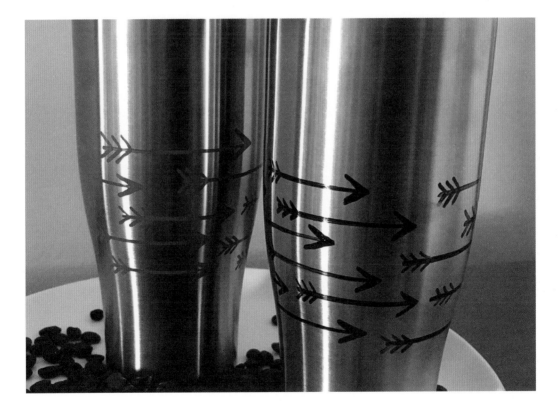

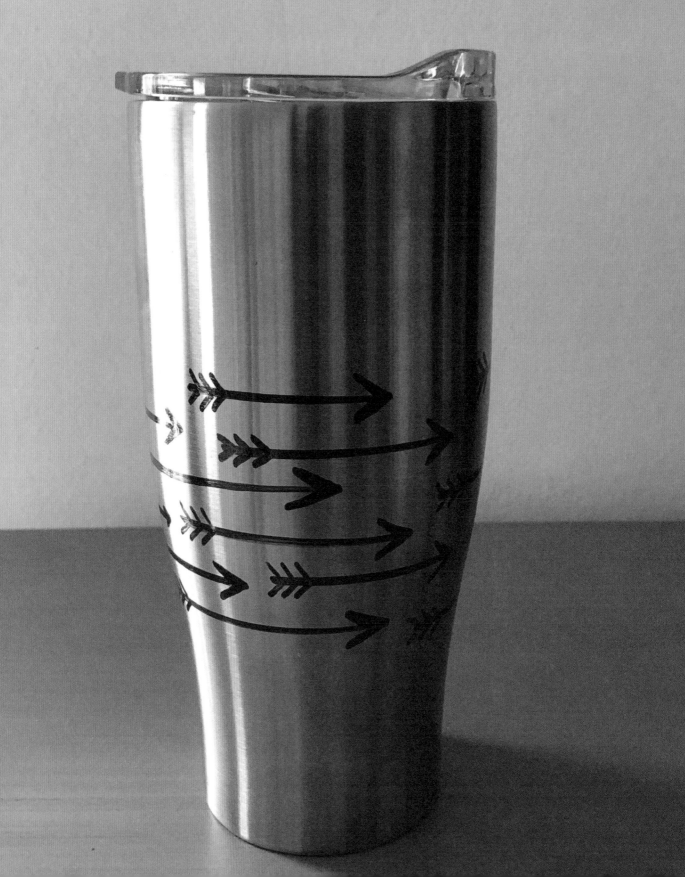

Step 1—Thoroughly wash and dry your travel mug inside and out. Set the lid of the mug aside.

Step 2—Sketch some designs to apply to your mug. (**Note:** If your mug has a brushed steel texture, take the direction of the grooves into consideration as they will make straight lines in the same direction very easy and diagonal lines a challenge. Another factor to consider is that the colors will deepen after being heat sealed in the oven. If the color is an important factor in your design, try testing colors on the bottom of the mug and heating it in the oven as described below in advance of creating your design.)

Step 3—Place your mug on a cardboard-covered work surface and apply your design. Rotate the mug as you apply the artwork, and take breaks as needed to prevent smearing of the art.

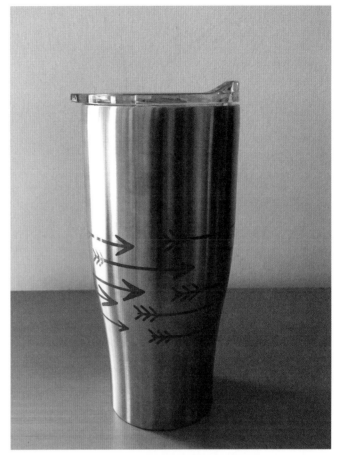

Step 4—Let your mug dry for several hours or, even better, overnight before placing it in the oven.

Step 5—Set your mug on a cookie sheet and place in the oven *before* turning it on.

Step 6—Heat the oven to 350 degrees and set a timer for 30 minutes. When the 30 minutes are up, turn off the oven but do not remove the object. Leave it in the oven until the oven cools completely.

Step 7—Replace the lid on your decorated mug and enjoy sipping a hot or cold beverage in style on the go.

**Care Instructions:** Gently hand wash and dry.

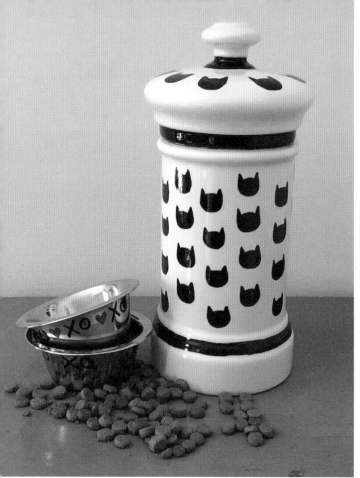

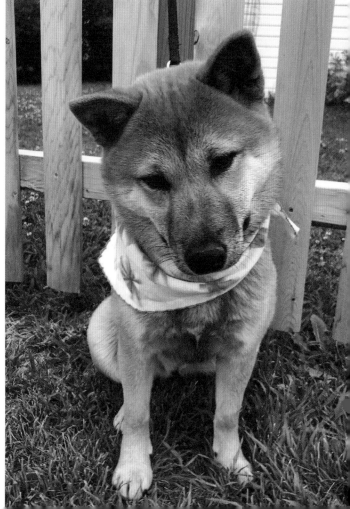

# CHAPTER 6

# PETS

Make your pet stand out from the pack by decorating their accessories
and household items with your unique designs.

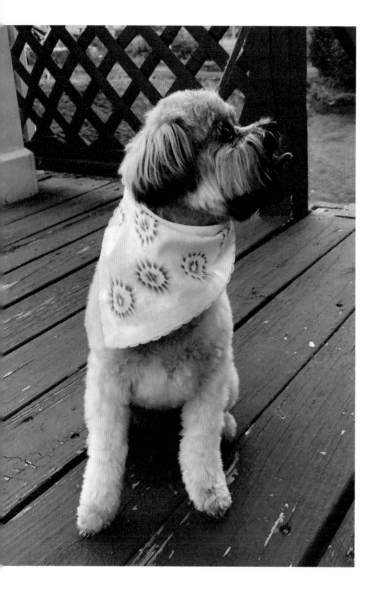

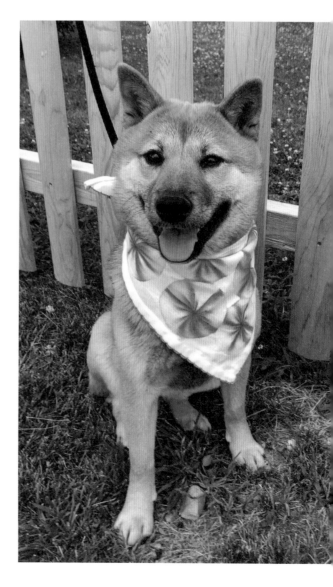

# BANDANAS—COLOR BURST BANDANAS

*Pamper your pets by sharing the Sharpie love. They will go pawsitively wild for these bandanas. Your pup will be the leader of the pack with this new look!*

**Supplies:**

- Light-colored bandana—A cotton fabric works best. Have at least two so you have a spare to practice the techniques on
- Permanent markers in a variety of colors and sizes
- Rubbing alcohol and a dropper or spray bottle
- Plastic trash bag or tarp

**Optional:**

- Hot iron or clothes dryer

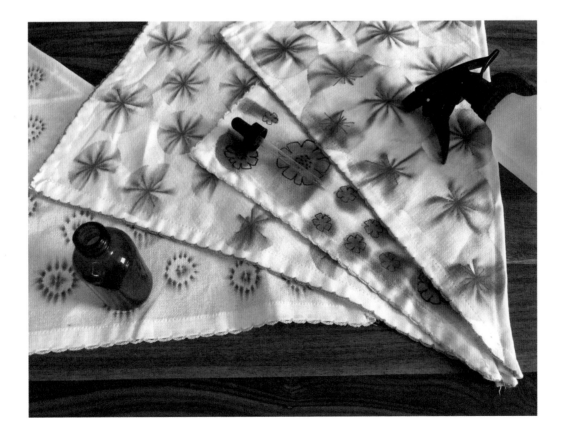

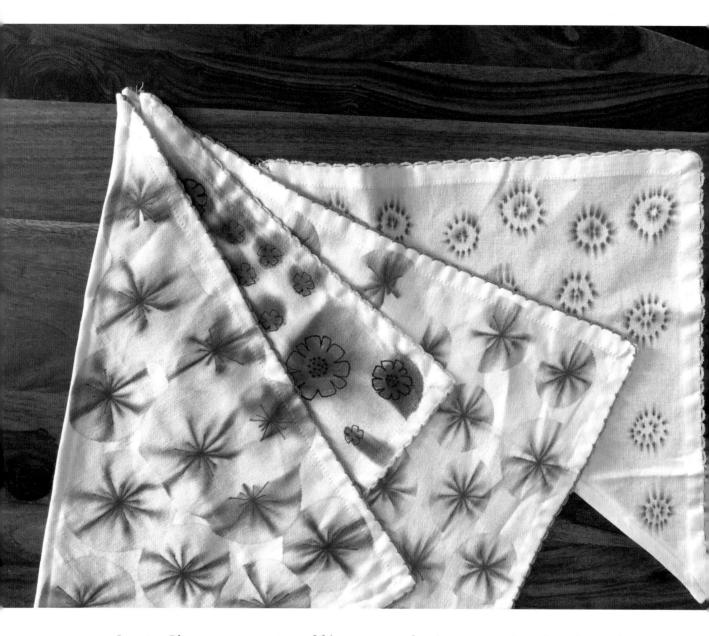

**Step 1**—Place your spare piece of fabric on top of a plastic-covered work surface and test out the different effects that can be achieved on your bandana. Try drawing shapes, such as starbursts, dots or triangles, on the fabric. Mist your drawing with rubbing alcohol using a spray bottle, or apply it to targeted areas using a dropper. Experiment with layering colors and adding line art to artwork once the alcohol has evaporated. (**Note:** The rubbing alcohol can be smelly, so make sure to work in a well-ventilated area.)

Step 2—Place your bandana on top of a plastic-covered work surface. You might want a fresh piece of plastic if the piece you used in step one has a lot of ink on it. Apply your design and wait for it to dry before applying any additional line art.

Step 3—Once your artwork is completely dry it can be heat set in a warm dryer or with a hot iron.

Step 4—Enjoy seeing your furry friend sport a new look!

**Care Instructions:** Wash in cold water and line dry for best results.

**TIP:** This technique can be used to decorate all kinds of items. If applying to a two-sided item, such as a pillowcase or T-shirt, make sure to place a piece of plastic-wrapped cardboard inside the item to keep the artwork from bleeding through to the reverse side.

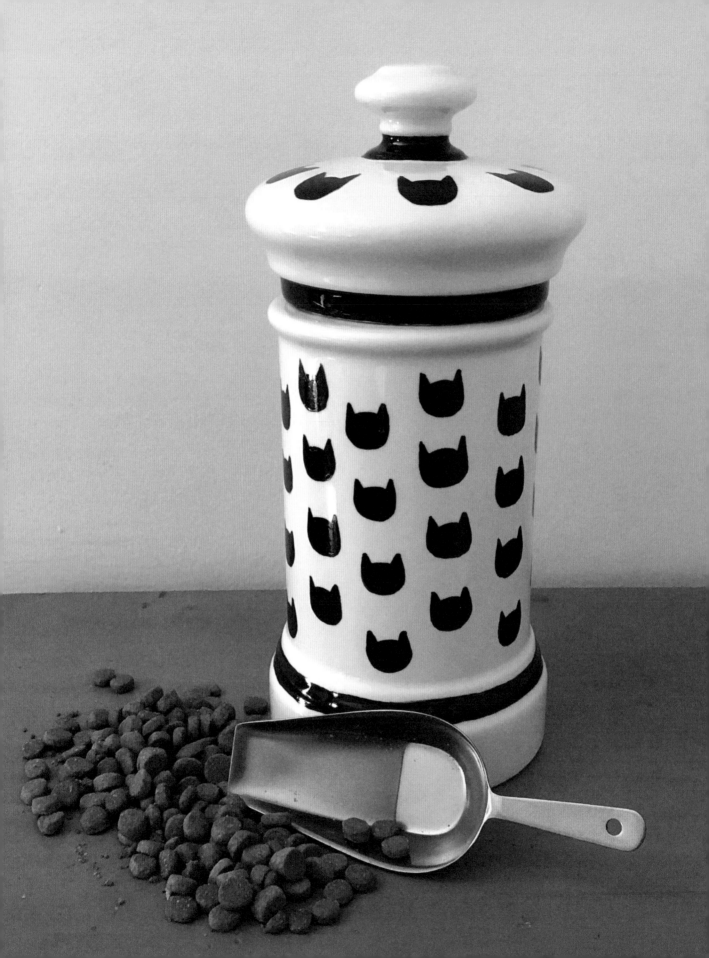

# FOOD CANISTERS—CAT CANISTER

*Add some character and charm to your food canister, so meal time with your pet is purr-fect!*

**Supplies:**

- Ceramic canister—A matte finish works best
- Oil-based Sharpies in a variety of sizes and colors
- Cardboard
- Pencil
- Oven and cookie sheet

**Optional:**

- Masking tape

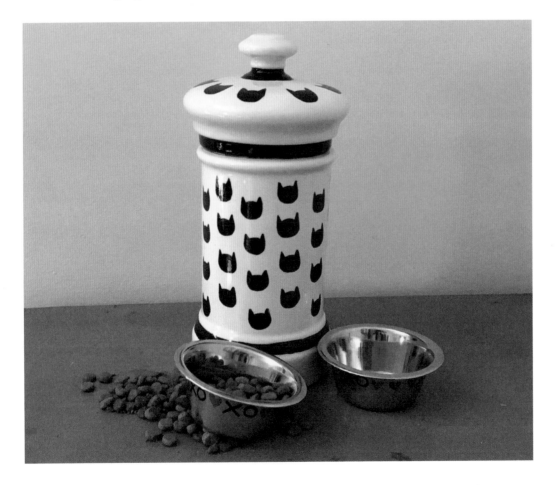

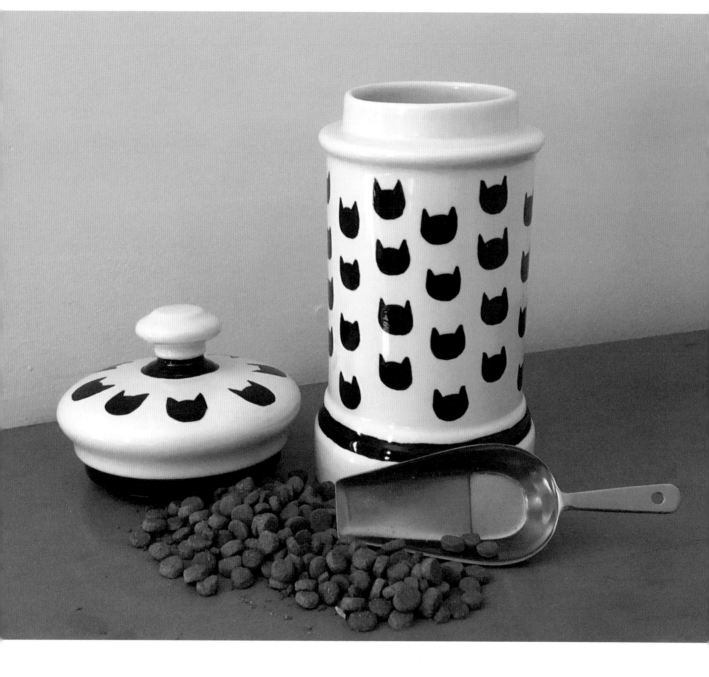

**Step 1**—Thoroughly wash and dry your canister.

**Step 2**—Sketch out ideas for a design. If decorating a large container, it can be helpful to block out areas using masking tape or stencils. Consider what the container will be filled with and what kind of animal you have. (**Note:** If the container will be used to store food, do not place designs on the inside portion of the canister.)

**Step 3**—Set the lid aside and place your canister on top of a cardboard-protected work surface. Apply your design to the container, taking time to allow areas to dry as you rotate it to decorate each section, then decorate the lid. (**Note:** If you used masking tape to block off areas, wait for the ink to dry thoroughly before removing it and cleaning up any untidy lines.)

**Step 4**—Let your canister dry for several hours or, even better, overnight before placing it in the oven.

**Step 5**—Set your canister on a cookie sheet and place it in the oven *before* turning it on. (**Note:** The canister should be upright so that none of the artwork is touching the cookie sheet. If your canister is tall you may need to adjust the placement of your racks in the oven.)

**Step 6**—Heat the oven to 350 degrees and set a timer for 30 minutes. When the 30 minutes are up, turn off the oven but do not remove the object. Leave it in the oven until the oven cools completely.

**Step 7**—Enjoy storing treats for your pet inside your lovely new canister.

**Care Instructions:** Gently hand wash and dry.

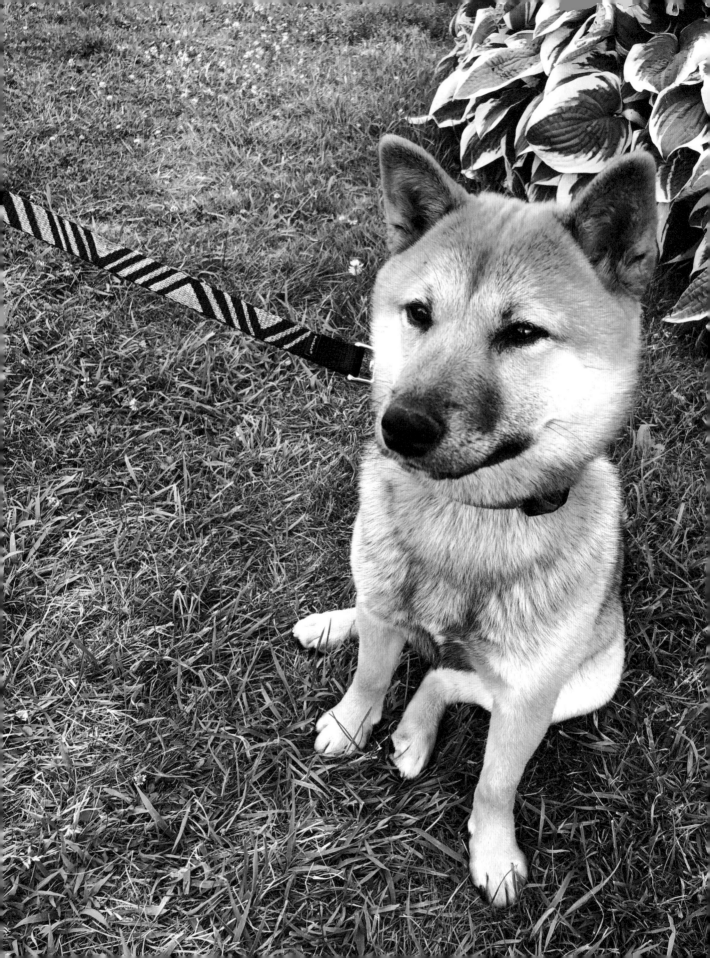

# LEASHES—ON THE LEASH

*Keep your pet looking good in the neighborhood by decking out their leash.*

**Supplies:**

- Nylon leash—This treatment also works well on a harness or collar
- Oil-based markers in a variety of sizes and colors
- Pencil and paper
- Cardboard

**Optional:**
- Masking tape

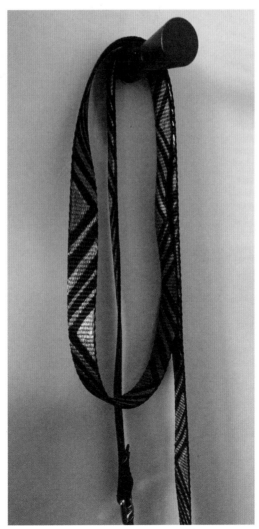

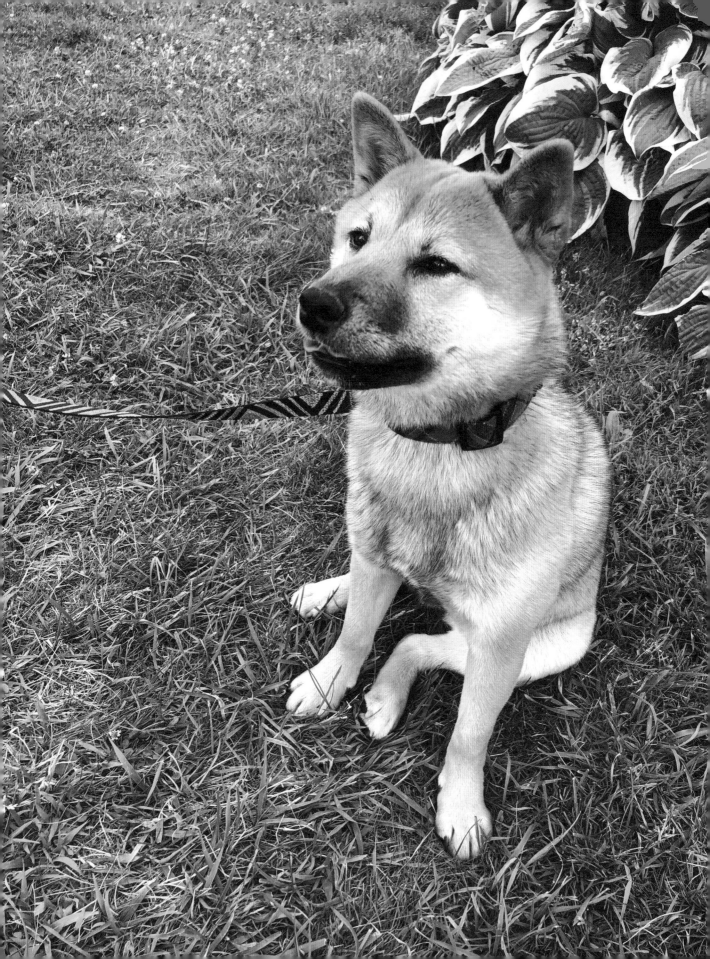

**Step 1**—Start by testing the colors you would like to use in an unobtrusive area, such as on the inside of the leash handle where the seam comes together. Sketch out your design based on the size of the leash.

**Step 2**—Place your leash on a cardboard-covered work surface and proceed to apply your design. Take your time—the leash is long and will need to be repositioned several times as you decorate it. Allow each section to dry before repositioning. (**Note:** You may want to use the masking tape to secure the leash as you decorate it or use the tape to create a striped design.)

**Step 3**—If decorating both sides, allow the first side to dry thoroughly before flipping it over to decorate the reverse side.

**Step 4**—Allow the leash to dry completely before putting it on your pal.

**Care Instructions:** Wash in cold water and line dry.

**TIP:** If you use a retractable leash, consider decorating the handle instead of the entire leash. Once the artwork on the handle has been applied and has dried, the handle can be coated with a clear spray coat to make it more durable.

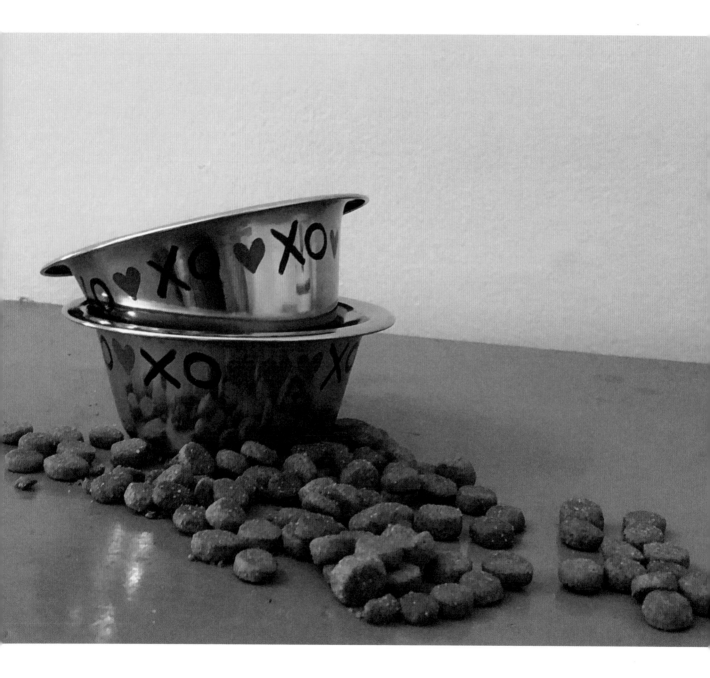

# STAINLESS STEEL FOOD BOWLS—BOWLS OF BEAUTY

*Sick of those boring old stainless steel food dishes? Spruce them up with some new decoration.*

Supplies:

- Stainless steel food bowls
- Oil-based paint pens in a variety of sizes and colors
- Pencil and paper
- Cardboard
- Oven and cookie sheet

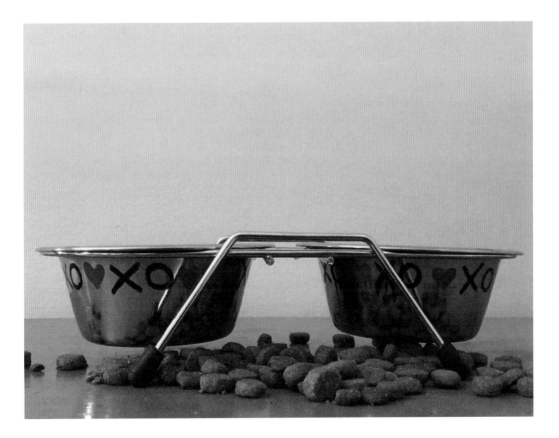

Step 1—Thoroughly wash and dry your bowls inside and out.

Step 2—Sketch some designs to apply to your bowls using your pencil and paper. (**Note:** Keep in mind that the markers are not food safe so the artwork should be applied to the outer portion of the bowls only.)

Step 3—Place your bowls on a cardboard-covered work surface and apply your design. Rotate the bowls as you apply the artwork and take breaks as needed to prevent smearing of the art.

Step 4—Let your bowls dry for several hours or, even better, overnight before placing them in the oven.

Step 5—Set your bowls on a cookie sheet and place them in the oven *before* turning it on.

Step 6—Heat the oven to 350 degrees and set a timer for 30 minutes. When the 30 minutes are up, turn off the oven but do not remove the object. Leave it in the oven until the oven cools completely.

Step 7—Share the stylish new set with your furry friend!

**Care Instructions:** Gently hand wash and dry your bowls. (**Note:** If left over wet food has dried to create a tough surface allow the bowls to soak in warm soapy water and then gently hand wash and dry.)

> **TIP:** If the color is an important factor in your design, try testing colors on the bottom of the bowl and heating it in the oven as described below in advance of creating your design.

# CONCLUSION

I hope that you enjoyed the projects in this book as much as I did and that they are just the beginning of your Sharpie experience. The techniques shown in this book have multiple possible applications and the only limit is your imagination. Why not increase the scale of some of the projects to give your home a top-to-bottom Sharpie makeover? Sharpies can have dramatic results when applied to rugs, wallpaper, tablecloths, window treatments, and furniture too!

Thank you for buying this book and making it part of your crafting adventure!

—Jess